LEGENDARY LOCALS

OF

MONTCLAIR
NEW JERSEY

D0945518

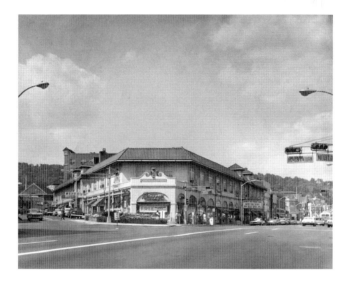

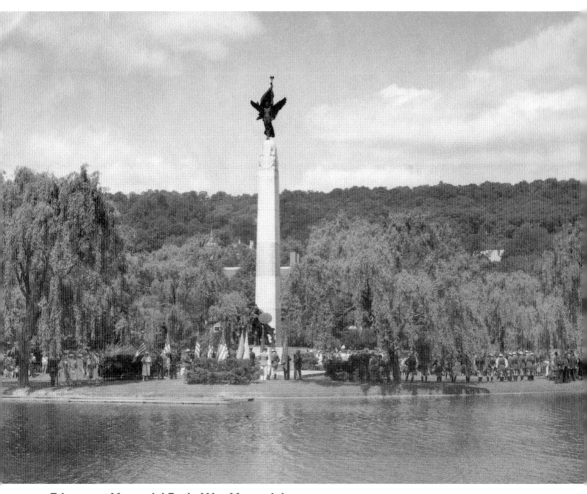

Edgemont Memorial Park, War Memorial
The Edgemont War Memorial serves as the town's symbol. (Courtesy of Montclair Public Library, Local History Collection.)

Page 1: Montclair Center, 1963
Montclair Center is the heart of Montclair's downtown. (Courtesy of Montclair Public Library, Local History Collection.)

LEGENDARY LOCALS
OF

MONTCLAIR
NEW JERSEY

ELIZABETH SHEPARD AND MIKE FARRELLY

Legendary Locals is an imprint of Arcadia Publishing
Charleston, South Carolina

Printed in the United States of America

Library of Congress Control Number: 2012947240

For all general information, please contact Arcadia Publishing:
Telephone 843-853-2070
Fax 843-853-0044
E-mail sales@arcadiapublishing.com
For customer service and orders:
Toll-Free 1-888-313-2665

Visit us on the Internet at www.arcadiapublishing.com

Dedication
To my father, for sharing his love of Montclair's history.

—Elizabeth

To my wife, Loretta, who not only supported me and provided level-headed advice on this project, but who is the hidden genius behind everything I do.

—Mike

On the Front Cover: From left to right:
(TOP ROW) Elizabeth Blackwell, physician (Courtesy of Montclair Public Library, page 100); Frederick Douglas, physician (Courtesy of Montclair Public Library, page 84); Mary Kimberly Waring, educator (Courtesy of Montclair Public Library, page 113).
(BOTTOM ROW) Aubrey Lewis, businessman and FBI agent (Courtesy of Montclair Public Library, page 124); Lillian Gilbreth, scientist (Courtesy of Montclair Public Library, page 77); Ella Mills, philanthropist (Courtesy of Montclair Public Library, page 38); Philip Doremus, businessman (Courtesy of Montclair Public Library, page 17).

On the Back Cover: From left to right:
George Walker, composer, with Katherine Dougherty, librarian (Courtesy of Montclair Public Library, page 62); George "Mule" Haas, baseball player (Courtesy of Montclair Public Library, page 123).

CONTENTS

ACKNOWLEDGMENTS

Our thanks go to the Montclair Public Library for allowing us to scan its images and use its extensive local history collections. We especially thank Bill Fischer, the head of the local history collection at the library, for all of his support and assistance. In addition, we thank the Montclair Historical Society for allowing us to scan images from its holdings.

Finally, Elizabeth thanks her father, Royal Shepard Jr., for reading her manuscript and providing her access to his extensive local history files.

Mike Farrelly wishes to thank the many people who have provided support and information to fuel his passion for Montclair history over the years, including Elizabeth and Royal Shepard. There are too many to mention by name, but not too many to thank. He would also like to express his appreciation to the nameless people who supplied newspaper clips to the public library, and to the librarians who preserved that information. That was the treasure trove from which most of these histories were taken.

Unless otherwise noted, all images in the book appear courtesy of Montclair Public Library, Local History Collection.

INTRODUCTION

In the 2004 movie *Along Came Polly*, Ben Stiller plays a character named Reuben Feffer, a very cautious insurance man. After getting married, he and his bride go to St. Barts on their honeymoon. His new wife, however, fools around with a muscular scuba diver. Reuben returns home to New York alone, and then meets an old middle school girlfriend, Polly Prince, played by Jennifer Aniston. Eventually, they get married. At one point in the movie, Feffer promises Prince that they will move to Montclair. That's it! No set-up. No second unit shots of Montclair. The supporting characters do not try to convince them to move to Montclair, or not move there. There are no long-winded descriptions of the New Jersey town. It doesn't come up in the movie again. And that is the point. There really isn't much need to explain Montclair. People just seem to know what Montclair is about.

It is a suburb of New York City, about 12 miles away. It is easy to get to Manhattan, but, quite frankly, one can live in Montclair for years and never feel the need to go into the big city.

Montclair is home to wonderful restaurants, a lively music scene, a great art museum, good schools, and quite a few churches. There aren't as many live theaters as there used to be, but one can still catch quality productions every once in a while. Montclair, as it has been for 140 years, is still home to artists, writers, actors, and musicians. There are plenty of shops offering everything one could need. One can go to work in New York and escape the hustle and bustle of the city every night. If your taste and personal wealth warrant it, there are enormous mansions to live in, on the hill and in expensive cul-de-sacs. Just plain folks live here, too. People are as politically involved and socially involved as ever. It seems that people in Montclair are always willing to donate money or time to worthy causes.

Montclair is home to a great number of professionals—men and women who have achieved success in business, law, science, medicine, education, politics, and the arts. They join a long chain of professionals who have made Montclair their home. Some accomplished great things after they moved elsewhere. Some rose to prominence in their fields, then moved here. Some spent their entire lives here. It is easy to understand why the first professionals came to Montclair in the 1860s. A brand-new railroad allowed them to get away from the smog and filth of the New York of their day.

When asked what they appreciate about Montclair, residents often cite its diversity. This is not to say that absolute equality reigns, or that all races and cultures always get along. But, when disagreements arise, intelligent people come forward to argue their points of view on all sides. They tend to do so in a civilized and informed way. Diversity, in this case, means that the resolution of disagreements is not always a foregone conclusion favoring rich white men. People from different races, different cultures, and different countries live in Montclair. Unlike many towns, they do not live sequestered in ethnic pockets. There is no Chinese section, no Polish section, no Irish section. However, due to segregation and "red lining"—the policy of real estate agents to only show homes in one section of town to certain ethnic groups—there is an African American section of town. There is a section of town where most Italians ended up, whether due to red lining or to personal choice. These sections are not ghettos, or, at least, they aren't any longer. Many African Americans and Italians still live in these parts of town. There may be social and economic reasons keeping them there, but there is no "unwritten law" forcing them to live there. People from different ethnicities now live wherever they want to live in Montclair. People like the African American artist Don Miller and his wife, Judy. The Millers may have felt compelled to live in the African American section at one time, but they moved to a different part of town. They faced resistance from their new neighbors at first. That resistance may still be the cause of hurt feelings and resentment, but that resistance has disappeared.

Jason Lemire grew up near the Millers. He mowed their lawn. He addressed an audience of supporters when he was kicking off a project to write a screenplay for a movie that was to depict Don Miller's

life. Lemire talked about how some of the neighbors weren't happy about an African American family moving into the neighborhood. He talked about how his parents told him that Miller was "special." But, his father added, Miller was special not because he was African American. He was special because he was a great artist.

African American composer George Walker does not live in the African American section. Frankie Faison, the noted actor, lived in the African American section, but has since moved to a different part of town. The social activist Mary Hayes Allen and her husband, William, did not live in the African American section. They lived on Valley Road. As mentioned above, quite a few Italian families still live in or near the Italian section. Now they can be found in every section. Diversity is apparent in the homes the residents choose for themselves.

Diversity in Montclair means that one may find herself standing next to people who have much less, or much more, money, or a lesser or a better education, or a lesser or a greater stature. It also means that we are not just a community of "firsts." We do not just stop at the first African American to get elected mayor, or the first Swedish American to get elected. We make every attempt to make sure that the right people are placed in positions of importance, whatever their race, nationality, or culture. Once again, it is true that not everybody agrees on who the best candidates for any job are. History sometimes shows that the decisions we made were wrong, that the people we picked weren't the best. We do not live in a fairy-tale land, but we do live in a place where race, ethnicity, nationality, and culture are not the major factors in determining how things happen. Many people want their children to be exposed to this environment. Perhaps that is why so many professionals choose to live in Montclair.

It is also true that women are not second-class citizens in Montclair. They were once, however. City directories before the late 1930s did not include the wives of famous men. Perhaps they would appear as the "widow of " in directories published after their husbands had passed away. The few histories we have focus on the men who started businesses, or paved the streets, or put in utilities, but not the women. This may reflect the national mentality of the time. Women weren't accepted as equal to men, but they are now. A close look reveals that women are the driving force behind most of the things that happen in Montclair.

Margaret Jane Power observed a child fall from a window in 1890. She was upset that there were no local hospitals, or clinics, and that the child had to be taken out of town for treatment. She and a small group of her women friends were the impetus behind the formation of Mountainside Hospital. Elizabeth Habberton and nine other women founded the Children's Home, which was financially supported and managed by those 10 women and their female successors.

Alice Hooe Foster and a small group of her women friends saw the need to provide support for young African American ladies in town. They formed the "Colored" YWCA, the only YWCA in Montclair. They met in Foster's home for the first few years, then in the Israel Crane House for 45 years, until a YWCA building was erected on Glenridge Avenue. Basically, African American women ran the YWCA. It was not completely segregated, and included interracial functions. It was fully integrated in 1953. Because Montclair was segregated, the YWCA felt the need to have an advisory board of white, upper-class women to oversee the operation. Perhaps it was the only way to get things done in those days.

Octavia Catlett and Mary Hayes Allen challenged the status quo in Montclair by marching into segregated establishments and demanding to be treated the same as any other customer. They became active in Montclair's fledgling NAACP. Catlett was president for many years. Jean Clark was one of the founders of the Montclair Recycling Center. For the first few years, she seemed to be the sole operator. Her sister, Beatrice "Betty" Evans, was the first female commissioner on the town commission. Olympia Dukakis and Jane Mandel were founding members of Montclair theater companies. Oliver Lake cofounded the World Saxophone Quartet. His wife, Marion, owns an alternative clothing store on North Fullerton, *Dem Two Hands*, though Marion would probably object to it being called an alternative store. In Montclair, it is simply a clothing store. Women probably own the majority of businesses in town.

In addition, there are women who have lived in Montclair and have accomplished great things elsewhere. Edythe Sydnor was a civilian attached to the Army Air Corps during World War II. After a variety of jobs, she trained as an airplane mechanic. At the end of the war, she was the crew chief of a racially and

sexually integrated engine repair crew. Sydnor was chosen to be the executive secretary for the Montclair Neighborhood Center, and ran unsuccessfully for the town commission in 1964. She helped pave the way for the Rev. Matthew Carter to become the first African American town commissioner in 1964. (Carter was reelected to the town commission and became the first African American mayor in 1968.) She finished out her career with the Essex County Division of Youth Services. During her working years, Sydnor met a Kenyan student and began to visit Bungoma, Kenya. She sold her own handiwork to raise money for a dilapidated school in Bungoma. It became the focus of her life. She organized large-scale fundraising activities and raised enough money to expand the tiny school into a 12-classroom building and to build a 320-student secondary school in the Bungoma village of Miluki.

Ellen R. Malcolm graduated from the Kimberly School in 1965 and studied at Hollins College. She worked for Common Cause, a nonpartisan lobby that strives for more accountability on the part of government institutions. She was press secretary for the National Women's Political Caucus. From there, Malcolm went on to found EMILY's List, which funds and nurtures female candidates for the Democratic Party. "EMILY" stands for Early Money Is Like Yeast. Malcolm, a cochair of Hilary Clinton's campaign for the presidency in 2007, is now a director of the National Park Foundation.

It is impossible to mention every famous woman who has ever been involved with the growth of Montclair in the narrow confines of this book. As a matter of fact, there isn't enough space in this book to write about all the legendary locals who live here or have lived here. With much regret, many notable people have been left out. Sometimes, it was because there wasn't a good photograph available. Some people were concerned about their privacy. But, basically, there just isn't enough room to cover everybody. Montclair is a wonderful place and home to many legendary locals.

CHAPTER ONE

Founding Families

Two events influenced the founding of Montclair. The first was in 1665, when members of the defunct New Haven Colony approached East Jersey governor Philip Carteret about buying land at Newark Bay. They were angry that their colony had been merged with the Connecticut Colony a few years earlier. They had previously approached the Dutch governor, Peter Stuyvesant, about buying the land in 1663. But the English conquest of New Netherland in 1664 put an abrupt end to those talks.

First, they had to negotiate with the local Native Americans, the Hackensack tribe of the Lenni Lenape. The colonists sailed down Long Island Sound and arrived in Newark in October 1666. Having neglected to inform the local natives that they had a letter from the governor, the colonists were forced back onto their boat. A small group of the colonists made their way to the main Hackensack encampment. With the help of Samuel Edsall, a resident of Bergen Neck, they were able to strike a deal with a Lenni Lenape named Perro, who claimed ownership of the land. The deal was later approved by their chief, Oratem, or Oraton, and was formalized in 1667. Robert Treat and a small band of English settlers disembarked and started to build houses in the area that is now Broad Street and Market Street. They were religious by nature and called their settlement "New Worke," known as Newark today. Jasper and Alice Crane were among the original settlers. Crane was influential in the community and became the leader when Robert Treat returned to Connecticut. The western boundary of Newark was extended 11 years later, to the top of the First Watchung Mountain.

The first settlers of Newark were content to remain in "downtown" Newark. Their children and grandchildren, however, wanted more room and started moving north and west. That brought Nathaniel and Azariah Crane, grandchildren of Jasper and Alice, to Montclair in 1699.

The second event that influenced the founding was the purchase of 10,000 acres along the Passaic River by 14 Dutch families in 1679. The land, which they called Acquackanonk, consisted of present-day Paterson, Clifton, Little Falls, and parts of Passaic. Johannes Hendrike and Maritje Speer, original purchasers, built a house near today's Great Notch. Their children and grandchildren started buying land in nearby Montclair (part of Newark in those days). In time, so many Speers bought farms in the north end of town that it became known as Speertown.

The Cranes and other English families built homes in the southern end of town. The Cranes were the dominant family, so the area was called Cranetown. Dutch families built homes in the north end. The dividing line between the Dutch and the English was, more or less, Watchung Avenue, which was a crossroad between Valley Road and Grove Street. Watchung Avenue was later extended to the Morris Canal in Bloomfield, ending by an ancient tree that was believed to be haunted. Morris Canal boatmen called it the "Ghost Tree." In the mid-19th century, Watchung Avenue was known as "Old Oak Tree Lane." There is still a little street called Old Oak Tree Lane, where Watchung Avenue ends, near the Parkway in Bloomfield.

The original Dutch and English families were mostly farmers. People developed trades, like blacksmithing and shoemaking, to earn extra money, but almost everybody had to be a farmer. They spent most of their

lives within a few miles of the place where they were born. School was somewhat of a luxury. Houses were small, as homebuilders had to dig out the foundation with their own hands and cut and mill the lumber themselves. It wasn't all that much harder to shape brownstone blocks. They had to make their own nails or cut the ends of the logs to fit together with pegs.

Most houses consisted of two rooms. One room was a kitchen, and the other was a family room. People usually slept in lofts above the family room. A fire was constantly burning in the kitchen hearth, which made it beastly hot in the summer, but provided essential warmth in the winter. Houses often burned down, and detached kitchens did not really come into being until the 1780s and 1790s, when building materials were a little easier to obtain. There were no glass factories in America, so windows had to be imported from Europe or made by local craftsmen.

The Dutch preferred stone houses. Each room in early Dutch houses had its own front door. In order to take advantage of heat from the sun, these homes were oriented to the south. The English usually built frame houses that resembled their former homes in New England. These homes, also consisting of two rooms, often had a central hall. One of the hallmarks of a Colonial-era English home was an oven that was exposed on the outside. Clapboards were put over the kitchen chimney on the upper level to keep heat in, but the lower portion, where the cooking fire burned all the time, was left uncovered, to prevent the clapboards from drying out and blazing up.

Except for a few English raiding parties, Montclair was basically left alone during the American Revolution. If soldiers confiscated goods from a house, the owners were allowed to file a claim. A few such claims from the area around Montclair are preserved in public records. No battles ever took place in the area. The Continental Army maintained lookouts on the mountain. The English army remained in Manhattan for several years, and basically chopped down every tree on the island to build shelter or to keep warm. Most of the colonists were concentrated near present-day Clifton, where the steep hill created a natural fortress. In October 1780, Generals Washington and Lafayette moved several regiments to Cranetown. Washington picked the largest house in town, that of William and Mercy Crane, to be his headquarters. The house is gone, but a plaque on a boulder at the corner of Valley Road and Claremont Avenue marks the spot. Lafayette was to raid a Hessian supply depot on Staten Island and lure the Hessians back to an ambush. The French soldiers were to row across the Kill Van Kull at night and surprise the Hessians. Because the weather had been terrible in the weeks leading up to the planned attack, roads were rutted and muddy. The wheels of the wagons carrying the boats kept falling off. The boats did not arrive until morning. By then, the element of surprise was gone. Lafayette returned to Montclair. No Hessian or English troops ever followed. Washington remained in Montclair for a few more weeks, then went to winter quarters in New Windsor. The main army went back to Morristown.

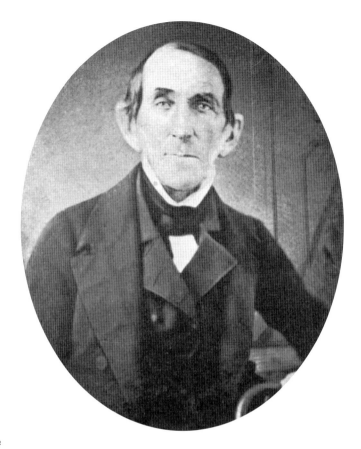

Israel Crane

Crane studied for the ministry at Princeton, but left for health reasons. He entered into business and was, by far, the most prosperous Montclairian of his generation. He was nicknamed "King" Crane. In 1796, Crane and his wife, Fanny, built a two-story Federal Revival house on Glenridge Avenue (then part of the meandering Old Road). He ran a successful general store and cider mill near his house. He started a quarry in Newark, which employed 300–400 men. He was one of the first to take advantage of Alexander Hamilton's Society for Useful Manufacture in Paterson. The society used waterpower from the Great Falls to power machinery. Crane built a cotton mill there. He dammed up Toney's Brook near the future site of the Bay Street train station to power a cotton mill. When the Morris Canal built a water turbine–powered "plane," or lift for the boats, in Boonton, Crane built a mill there to use the falling water from the spillover flume. Crane was a commissioner of the Morris Canal. He became a commissioner of the Turnpike in 1806. It began at his quarry in Newark and provided a straight path between Newark and farms in western Essex County. It was a toll road. Travelers had to pay toll keepers to "turn the pikes" out of the way in order to proceed. Travelers who were not in a hurry continued to take the winding, but free, Old Road from Newark. The turnpike wasn't successful at first. Other commissioners started selling their shares. Crane became president, then the sole owner. He made a success of it. He cut a road (now Lackawanna Plaza/Israel Crane Way) from the turnpike to his store. The turnpike was turned over to Essex County after Crane died, and is now Bloomfield Avenue. Crane was a teetotaler, but he kept a small amount of liquor on hand as medicine for his son, James, who suffered from asthma. James and his wife, Phebe, put a third floor on the house.

Starting in 1920, the Crane House was occupied by the "Colored" YWCA (see page 103). It was to be demolished in 1965 when the Y wanted to erect a new building on the site. The Montclair Historical Society, formed to protect the house, moved it to its present location on Orange Road and still uses it for tours and functions today.

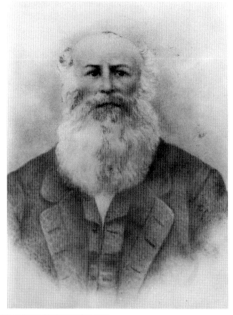

Rynier Speer

Rynier Speer was born at the family homestead, 612 Upper Mountain Avenue. He and his wife, Charity, ran a hotel in Little Falls. They inherited the homestead when his parents died. He was a surveyor, justice of the peace, and a sportsman, opening the house to hunters and fishermen on weekends. He called his home The Sportsman's Hotel.

Aaron Sigler

In the 1790s, the Sigler family bought a great deal of property in the north end of town. Aaron Sigler, son of Abraham and Phebe Sigler, built a house at 86 Alexander Avenue around 1836. He and his wife, Caroline, were farmers. William and Nellie Hamilton started a dairy farm there around 1910 when the Siglers' daughter, Ellen, moved out. Parts of the farm became Yantacaw Brook Park.

Jared Erwin Harrison

Harrison was born at the family farm on Valley Road. He and his wife, Catherine, built a house, now the rear portion of 249 Valley Road. He was a director of the Newark & Bloomfield Railroad and served on the Bloomfield Township Committee before Montclair split from Bloomfield. Jared and Catherine's children developed parts of the farm to create Erwin Park, named for their father.

Riker's House, 116 South Fullerton Avenue

The Riker family, descended from Abraham Rycken, who purchased Riker's Island in 1664, bought land between Orange Road and Elm Street. David and Joanna Riker, of 161 Orange Road, came here in 1802. Joseph W. Riker was a carpenter and a beekeeper, selling honey from the house. He and his first wife, Emeline, built this house about 1870.

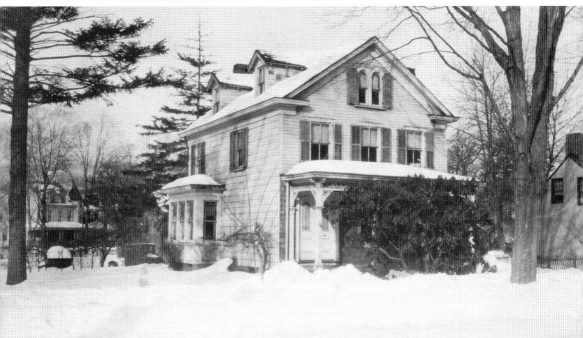

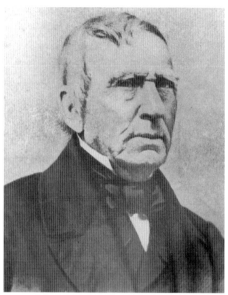

Capt. Joseph Munn
Munn commanded a company of Essex County militiamen during the Whiskey Rebellion in 1794. He and his wife, Martha, bought a lot at the corner of Valley Road and Church Street in 1801 and built a tavern, now the parish hall of the Evangelical Covenant Church. Munn was a Mason, and the tavern served as the area Masonic lodge. He was also in the hat business.

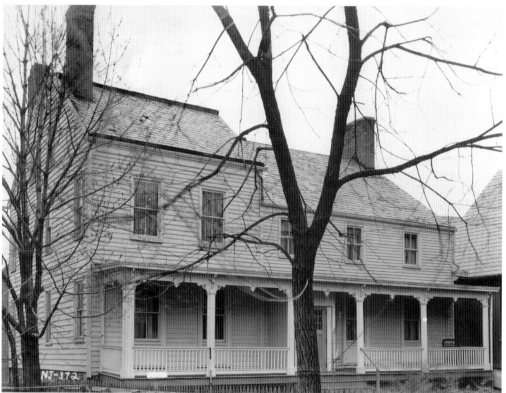

The Munn Tavern
Joseph and Martha Munn built this house and tavern in 1802 and lived here until 1822, when Joseph built a new tavern on Bloomfield Avenue. The Munn Tavern served as Montclair's first public library until 1904, when it was moved to make way for the Carnegie Library. The library is now part of the Unitarian church complex. (Photograph by R. Lacey Merritt.)

Philip Doremus
Doremus's father, Peter, built a general store on the Turnpike (Bloomfield Avenue) at North Fullerton in 1811. Philip Doremus studied merchandizing in New York, and, in 1848, returned to Montclair. He built a new store on the site of his father's store in 1853 and again in 1890. He was a founder of the Montclair Bank and the Montclair Savings Bank.

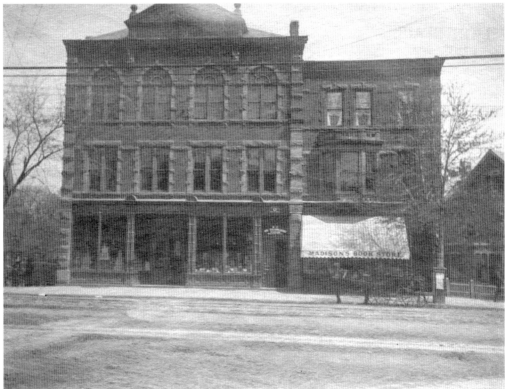

463–469 Bloomfield Avenue
This is the store that Philip Doremus built in 1890. It got a new facade in the 1940s. Doremus stopped selling farm implements and the general merchandise that his father sold, and instead specialized in groceries. The space from 463 to 465 Bloomfield Avenue was part of the Doremus store. It has been painted, but still shows the original 1890 facade. Philip and his wife, Hester, lived on the Old Road (Glenridge Avenue).

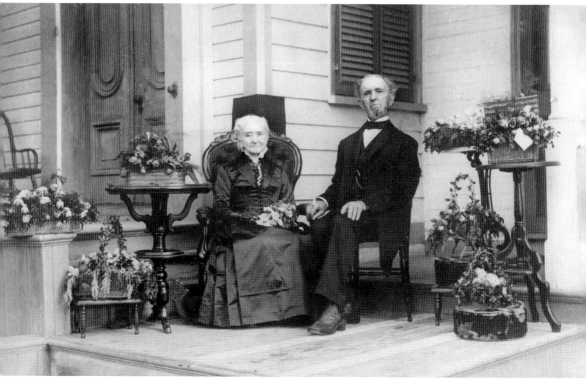

Joseph and Lydia Baldwin
The Baldwin family owned well over 1,000 acres in the south end of town. Most of the Baldwins were farmers, and the Baldwin Apple was named for the family. Lydia was born in 1807, and Joseph was born in 1808. The couple is shown here on their golden wedding anniversary. The modern-day Baldwin brothers of television and film are descended from this branch of the family.

Howe House, 369 Claremont
James and Susan Howe had been slaves on Nathaniel Crane's farm, and were freed some time before 1831. Crane willed them a house and six acres of land. Howe did odd jobs to earn a living until he became blind. Montclair children of all races loved him. They enjoyed going to his house and listening to his stories of the old days. (Courtesy of Royal Shepard.)

CHAPTER TWO

Newcomers

Montclair became part of Bloomfield when Bloomfield separated from Newark in 1812. Known as West Bloomfield, it was a sleepy, rural town, although men like Israel Crane were building roads. Crane and Peter Doremus set up general stores, and Joseph Munn built a tavern in the center of Cranetown. Simon Brown opened a tavern somewhere in or near Speertown. Thomas Davis set up a sawmill somewhere around Bay Street, and Peter Vreeland built one in the north end of town. Israel Crane built his cotton mill on Toney's Brook in 1812. Actually, there were two buildings, one a cotton mill, the other a woolen mill. In 1827, Henry Wilde leased those mills and started to produce woolen shawls. Montclair was connecting with the outside world.

In 1854, citizens of West Bloomfield (Montclair) and Bloomfield obtained a charter from the state legislature to build a railroad. Enough capital was raised by 1855 to build the Newark & Bloomfield Railroad. The Morris & Essex Road Company operated the line and held the majority of the stock. Regular operation began in 1857.

The railroad brought New York businessmen into the area. New York was a crowded city with poor sanitation. Coal furnaces made the air smoggy. Newcomers were attracted to Montclair's clean, healthful environment. The train made it possible for residents to raise their families in Montclair and commute to their businesses in the city.

With the advent of a wealthier population, several excellent private schools were established, and this in turn brought in even more New Yorkers. Warren Holt built Mount Prospect Institute on property owned by his in-laws, the Parkhursts. It provided a high-quality education to a select number of students. The Rev. David A. Frame had been the principal of the Bloomfield Academy, considered one of the region's best preparatory schools. He brought everything he learned to Montclair when he set up Ashland Hall. Ashland graduates included judges and congressmen. The Rev. Ebenezer Cheever opened the Hillside Seminary for Young Ladies on Hillside Avenue. A few years later, the Rev. Aaron Wolfe and his wife, Laura, assumed control of Hillside Seminary, adding a boarding department. Young ladies from as far away as San Francisco studied at the seminary, as did the daughters of prominent local families (see page 112). Not to be outdone, school board president John J.H. Love insisted that the public schools offer the highest quality education. Superintendents John Taylor, John Gross, and, most important, Randall Spaulding, devoted themselves to implementing Dr. Love's vision. Randall Spaulding arrived in 1874 and served as principal and then superintendent for 38 years.

Day travelers to West Bloomfield often confused it with Bloomfield, and it was not uncommon for folks to buy railroad tickets to the wrong place. Mail was often mixed up. In 1860, citizens of West Bloomfield voted to change the name of the town. Although the name Eagleton received the most votes in a nonbinding election, a petition to call the town Montclair caught the public's imagination. The name was changed, but Montclair was still a political subdivision of Bloomfield.

In 1866, Julius Pratt and a few other men, discouraged with the existing railroad, obtained a charter for a new one. Pratt organized the Montclair Railway Company and started looking for a railroad company

to build the route. The New York & Oswego Midland Railroad offered to lay the tracks. The line was originally to run from the New York state line to Jersey City. The 1866 charter allowed property owners in every township through which the railroad passed to establish committees. The purpose of these committees was to issue bonds sufficient to raise the $4 million that the railroad was expected to cost. It is important to remember that committees, not municipalities, issued the bonds. The Montclair committee issued $200,000 in bonds at a seven percent interest rate.

Property owners in Bloomfield were satisfied with the status quo and did not agree to fund a new railroad. In 1868, the citizens of Montclair, anxious to build the new railroad, voted to secede from Bloomfield.

In 1873, the New York & Greenwood Lake Railroad, run by the New York & Oswego, began operation. That year also saw the beginning of a nationwide financial panic. The railroad faltered and could not provide enough money to the various townships to pay interest on the bonds. Responsibility to pay fell on the townships, since the bonds were issued under their watch. The Township of Montclair defaulted, but argued that, since it did not issue the bonds directly, it was not bound to make good on them. Bondholders organized a legal challenge to that position. After 10 years, it went to the US Supreme Court. In *Montclair v. Ramsdell*, the justices ordered Montclair to pay the bondholders. By 1883, interest and principal amounted to $400,000. Montclair property owners realized that this was, in effect, a lien on their land. They elected three very capable men, Thomas Russell, Stephen Carey, and George Farmer, to the township committee, specifically to deal with the problem. These men pledged their personal wealth in the amount of $195,000 as collateral to secure a low-interest loan to pay off interest on the bonds and to buy back as many as possible. The Mutual Benefit Life Insurance Co. provided the loan.

Financial trouble notwithstanding, property values in Montclair skyrocketed with the new railroad. New York businessmen and their families poured into the town. The population went from 2,000 in 1857 to 4,000 in 1876, to 7,000 in 1890. There were no statewide or national companies to provide infrastructure, so Montclair citizens had to do everything themselves. They organized fire companies, a water company, and a gas company. Sewers were installed and roads were paved. Sidewalks were originally made of wood, but flagstone later became popular. The newcomers forged a new kind of community; no longer a rural backwater, Montclair was now a vibrant suburb of New York.

Various groups have come to Montclair for a host of reasons. Italians came to escape violence in their country. Population growth and crop failures in Sweden brought over one million Swedes to the United States in the late 1800s and early 1900s. Jim Crow and racial hatred drove many African Americans from the rural South to the North at the turn of the 20th century and again in the middle of the century. Many came to Montclair from Virginia in the first wave. Contrary to popular belief, not all African Americans came to work as servants in the houses of the rich. Quite a few were professionals who set up their own businesses. Montclair was segregated, but word got around, especially in the African American newspaper *Amsterdam News*, that Montclair was a decent place to live.

Julius Pratt

Pratt graduated from Yale and worked in his father's ivory business. He and his wife, Adeline, moved to Montclair in 1856. He was active in the town's growth and founded the New York & Greenwood Lake Railroad, because he thought the first railroad was too slow. Pratt also founded the water company. He suggested the name Montclair when West Bloomfield became tired of being confused with Bloomfield. (Photograph by Kochne.)

48 Elm Street

The Pratts brought seeds from New England and planted the elm trees that gave the street its name. The Pratts were active in the Congregational Church and supported missions. Their daughter, Gertrude, wasn't able to attend her mother's funeral because she was preaching in Mexico. Robert and Lillian Martin started a funeral home in this structure in 1954, and it has been Martins Home for Services ever since.

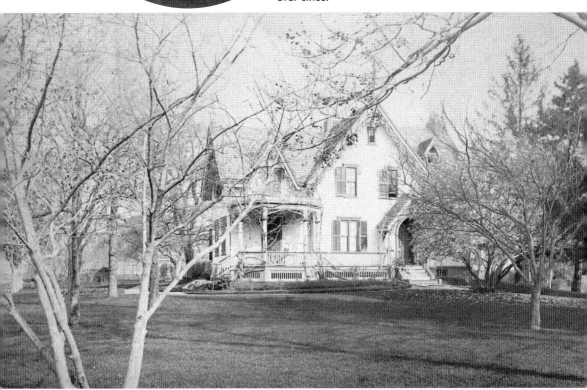

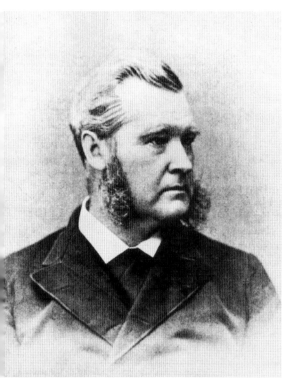

Thomas Russell

Russell emigrated from Scotland in 1850. He and his wife, Isabel, moved to Montclair in 1874. He was the superintendent of the Clark Thread mills in New York and Newark. As a member of the township committee, Russell was instrumental in bringing gas lamps to Montclair. His credit and that of his friends allowed Montclair to borrow the money needed to pay Greenwood Lake Railroad bondholders in 1883.

Three Russell Terrace

Thomas and Isabel Russell bought this house from their friends, the Wildes, and gave the house the Victorian charm seen here. It has since been altered and now sports an Italianate look. The Russells' daughter, Mary, contracted typhoid. The noise of delivery wagons disturbed her as she lay in bed, so the Russells covered their driveway with straw to cut down on the sound.

Charles S. Schultz

Schultz, whose parents emigrated from Bohemia, became successful in business. He was the president of the Hoboken Bank for Savings for 40 years. Architect Michel LeBrun did some work for the Hoboken Bank, and when he and his wife, Olivia, moved to Montclair, they convinced their friends, Charles and Lucy Schultz, to move there as well. LeBrun designed a house, at 30 North Mountain Avenue, for them. The Schultzes called it Evergreens. Their granddaughter, Molly, bequeathed Evergreens to the Montclair Historical Society.

Schultz had broad interests beyond his business. An inventor and collector, he installed a machine shop/laboratory on the third floor of his house, with equipment driven by a steam-powered belt system. He was a two-term president of the New York Microscopical Society, and he collected scientific apparatus. He put a large telescope on the roof of his home. He collected pottery fragments from Mexico and the American West, and brought home jade figurines from Asia. His library contained an impressive collection of books and housed custom-built display cabinets featuring all the items he collected during his worldwide travels. Perhaps the most impressive piece was a model of the Taj Mahal carved from alabaster and covered by a glass dome. His art collection included *Breaking Through The Clouds*, by Montclair's premier artist, George Inness Sr., although Molly Schultz always said that she did not like it very much. His son, Clifford, also traveled the world, collecting rocks and minerals. Clifford was often accompanied by his friend George Kunz, the chief gemologist for Tiffany & Company.

The Schultzes, especially Molly, saved everything, from rare pieces to items they used in their everyday life. Besides housing an impressive Montclair family, Evergreens is a museum that chronicles life from the late 19th century to the middle of the 20th century. (Courtesy of Montclair Historical Society.)

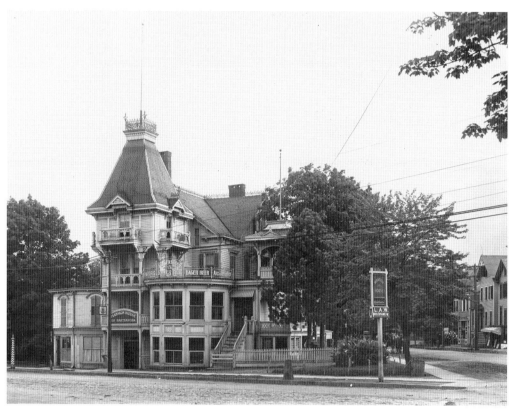

The Mansion House

In 1822, Joseph Munn built a new tavern on Bloomfield Avenue. It became Slater's Hotel after Munn retired. It was located where the municipal parking lot, across from the police station, is now. Around 1865, Edward Wright bought the hotel. Wright had remarkable taste in architecture, and he renovated the very plain building, giving it a Victorian, Queen Anne look.

Edward Wright's House, 51 Park

Wright was born in New Orleans in 1828. Around 1870, he and his wife, Loretta, built this house on Park Street, with the same architectural feel as his hotel. The Mansion House was demolished in 1908 and replaced, briefly, by the Montclair Theater (also demolished), a movie house with a stage for live performance. Mae West appeared at the theater in 1948. (Photograph by Mike Farrelly.)

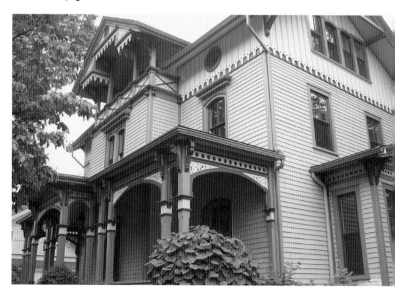

Samuel Wilde

Samuel Wilde and his brother, Joseph, took over his father's business. Samuel Wilde & Sons became Samuel Wilde's Sons. It sold spices and was one of the first firms to roast coffee for the wholesale grocery trade. Samuel became president in 1878 when his brother died. Like his father, Wilde was an abolitionist. He and his father gave sanctuary to runaway slaves in their store. He worked wholeheartedly in the church for African Americans that his father founded in Williamsburg, Brooklyn.

Samuel Wilde and his wife, Mary, came to Montclair in 1860. They bought property on South Fullerton in 1864 and, after careful planning, started building a house there in 1870. It took three years to complete, and was one of the largest houses ever built in Montclair. Wilde collected books, including many rare volumes. The library, probably the largest and best-stocked library in town, had a high-vaulted ceiling reminiscent of a Gothic church. To complete the effect, a pipe organ was installed in a loft-like structure, which matched the ecclesiastical architecture. The library became a meeting place for Montclair citizens as they organized the institutions and agencies that made the town a special place to live.

Wilde was particularly involved in the school system. He created a series of prizes to encourage academic achievement. He became a member of the township committee in 1871, and became a state assemblyman in 1872. The Wildes were originally members of the First Presbyterian Church, which stood at the corners of Bloomfield Avenue, Church Street, and South Fullerton Avenue (site of the current Hinck Building). They withdrew to become founders of First Congregational Church on South Fullerton. Wilde, a trustee of the church, was on the building committee. He and Mary gave liberally to the church. Even when he became an invalid, Wilde taught Sunday school every week, almost until the day he died. The pastor, Amory Howe Bradford, dedicated a chapel to his memory. The Wilde Memorial Chapel stood until 1914, when the original church and chapel burned down.

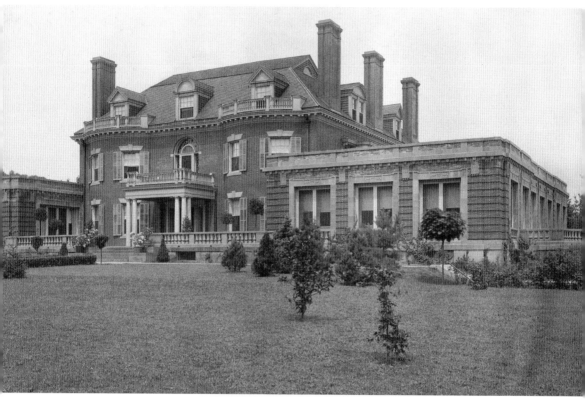

William Dickson

Dickson was a Carnegie Steel man. He started at Carnegie's Homestead Steel Works as a crane operator when he was 15 years old and rose through the ranks, becoming an assistant to the president and a director of the company. Andrew Carnegie surrounded himself with capable men, and Dickson was one of his protégées. Dickson also associated himself with Charles Schwab during Schwab's meteoric rise through the Carnegie organization. When J.P. Morgan bought Carnegie out in 1901, he selected Schwab to be the first president of US Steel. Dickson was a vice president. Schwab left to form Bethlehem Steel. Dickson disagreed with Morgan's labor practices and went to Midvale Steel, where he embraced labor reform, such as the eight-hour work day.

When Carnegie asked Dickson to write a history of the company, Carnegie hoped that Dickson would exonerate him for the role he played during the violent Homestead Strike. Carnegie publicly supported labor unions, but privately told his partner, Henry Frick, to do everything he could do to break the union's hold over the plant. Frick did not order the attack by the Pinkertons, but the steps he took to lock the union out made the collision unavoidable. Dickson refused to portray Carnegie in a noble light when discussing that period. However, Dickson and all of Carnegie's associates formed a club known as the Carnegie Veteran's Association. They met at least once a year for many years, even after Carnegie died. Dickson did write a history of the Veteran's Association, but barely mentioned the Homestead Strike. Carnegie and Frick had a falling out after the Homestead affair, and Dickson did not include Frick in the Veteran's Association book. W.H. Tener was another Carnegie veteran who came to live in Montclair. He lived on South Mountain Avenue.

Dickson and his wife, Mary, whose maiden name happened to be Dickson, built this house in 1903. William was a founder of the Montclair Art Museum and donated parkland to the town. Their daughter, Emma, caught a bit of her father's spirit. During World War I, most young women helped by sending items to the troops. Emma went to the front lines in France as a nurse. She married James Carswell, and they lived at 53 Melrose Place and at 54 Prospect Avenue. (Photograph by Floyd E. Baker.)

James F. Fielder
Fielder was from a family of New Jersey judges and politicians. He headed the state senate when Gov. Woodrow Wilson left office to become president, and became acting governor. He was reelected in 1914. Fielder left politics in 1917 to become a judge in the court of chancery, eventually becoming the vice chancellor. He and his wife, Mabel, lived at 139 Gates Avenue.

Percival Brundage
Percival and Amittai Brundage were latecomers to Montclair. In 1935, they moved to 169 Christopher Street. He was a senior partner at Price Waterhouse. After being appointed deputy director of the budget during the Eisenhower administration, Brundage became director in 1956. He consulted for the government after his retirement. He brokered the purchase of Southern Air Transport, a private airline, which has been rumored to have been a CIA front.

Wilhelm Steinitz

Wilhelm Steinitz was born in Prague in 1838. Sickly and with weak legs, he presented an unimposing figure when viewed from afar, but his dependence on crutches gave him a powerful upper body. He was very imposing when sitting across the table from someone. He worked as a journalist, but supplemented his income by wagering on chess. He moved to London and took part in chess tournaments there. Steinitz came in sixth in his first contest, which netted him £6. He then started winning tournaments. In 1866, after defeating Adolph Anderssen, considered the world's best chess player, Steinitz declared himself world champion. There was no official organization to sanction his championship, but nobody contested his claim. He held the title for the next 28 years. In 1886, he defeated Johannes Zukertort in the first officially sanctioned championship match. In 1892, he defeated the Russian champion, Michail Tchigorin, in a match played via telegraph. Steinitz was in New York, and Tchigorin was in Havana.

Steinitz was a respected commentator on the game of chess, writing books and articles that are still highly regarded. He advocated positional strategy, organizing his pieces in powerful patterns and waiting for his opponents to make a mistake. He studied the play of potential opponents in order to be ready to capitalize on their mistakes.

In 1882, he arrived in America and changed his name to William, and became a citizen in 1888. He had an office in New York, and he and his second wife lived at 398 Upper Mountain Avenue for several years in the 1890s. Steinitz often referred to his first wife and his deceased daughter by name in his writings. For some reason, he and the press only referred to his second wife as his "second wife." In 1892, he had a disagreement with his secretary, Arthur Williams, and let him go. Williams returned to the house on Upper Mountain Avenue with a shotgun and shot the new secretary, Edward Treiter, who lost an arm.

Steinitz's mental health began to deteriorate after 1894, when he was defeated by Emanuel Lasker. He imagined himself immensely wealthy. He tried desperately to develop a wireless telephone powered by telepathy. He slipped even further when Lasker beat him again in 1897. He died at the Manhattan State Institution in 1900. (Courtesy of the Cleveland Public Library Digital Collection.)

Oscar Carlson

Carlson's parents, Ludwig and Augusta, emigrated from Sweden in 1885. He joined the construction company formed by his father and uncle, and became president when his uncle retired. He served in the Navy during World War II. Carlson and his wife, Dicie, lived at 106 Inwood Avenue. He was mayor of Montclair from 1932 to 1936. Carlson (left) is seen here swearing in James McKee as the town clerk in 1933.

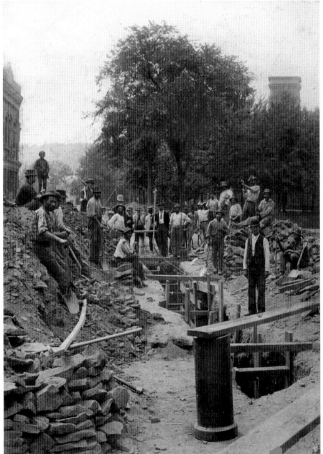

Italian Immigrants

Italians came to the United States to escape the wars of Italian unification. Most arrived without money, and many accepted work as laborers. Many of the Italians who came to Montclair in the early 1900s found jobs installing waterlines and sewers. They were the largest immigrant group to arrive in Montclair in the 20th century. They built homes and apartment buildings to rent out, mostly in the Pine Street neighborhood.

Abram P. Haring

On February 1, 1864, Confederate general George Pickett led about 13,000 men in a desperate effort to retake a supply depot at New Bern, North Carolina. Gen. Robert Hoke headed a column of about 4,000 Confederate soldiers who were to cross the bridge at Batchelder's, or Bachelor's Creek. Lt. Abram Haring and 11 Union soldiers guarded the bridge. It was a dark night. Lieutenant Haring had his men spread out, and told them to fire intermittently and to bark out commands as if they were calling out orders to several companies. They managed to hold the Confederates off for a couple of hours while one soldier went back for reinforcements. With a total of 150 men, Lieutenant Haring kept the Confederates off the bridge until morning, when daylight revealed their true strength.

Haring slipped through enemy lines and was able to alert a Union regiment of the attack. He then took some men and rode a military train, with cannons aboard, into the midst of the Confederate cavalry. The Confederate assault on New Bern failed. Haring was awarded the Congressional Medal of Honor. His military career ended in 1865 when he was wounded at the Battle of Southwest Creek in North Carolina.

Haring went to work for Stewart & Warren, a stationery supplier in New York. He and his wife, Emma, bought the Beatty farm (230–232 Valley Road) when they came to Montclair in 1876. A few years later, they had local architect Effingham R. North design a home for them at 66 Park Street. This site became the parsonage of Central Presbyterian Church. It was torn down to make room for the office building that stands there today. (Courtesy of the Congressional Medal of Honor Society.)

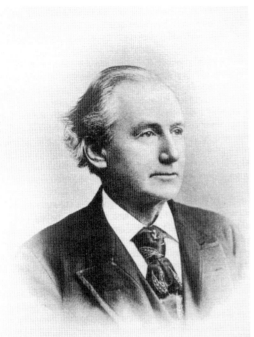

Stephen Carey
Carey founded a shipping brokerage. He and his wife, Sarah, came to Montclair in 1871. Their house was at the corner of Llewellyn and Orange Roads. When they died, their son offered the property to the town, but it refused. Later, when the town was interested in parkland, it had to pay $78,000 for the lot. The land was left undeveloped and is now known as Carey's Woods.

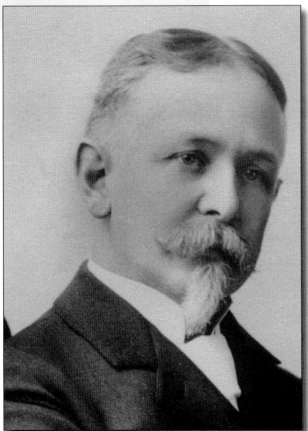

Dr. Morgan Ayres
Ayers studied at the College of Physicians and Surgeons. He and his wife, Sarah, moved to Montclair Heights in 1876. His practice extended into Upper Montclair. He served on the Montclair Township Committee and on the District 10 School Board (Upper Montclair). The Ayreses built a grand house at the corner of Lorraine Avenue and Park Street in 1894. It is now the convent at Lacordaire Academy.

Samuel Crump

Samuel and Anna Crump moved to Montclair in 1875, and built this house on Highland Avenue. Samuel started a label printing company near Walnut Street. He did not think public education in Montclair prepared boys for work in his factory. He was an advocate for technical education and led the group that got the subject added to the primary school curriculum.

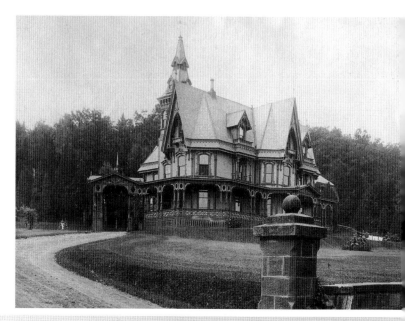

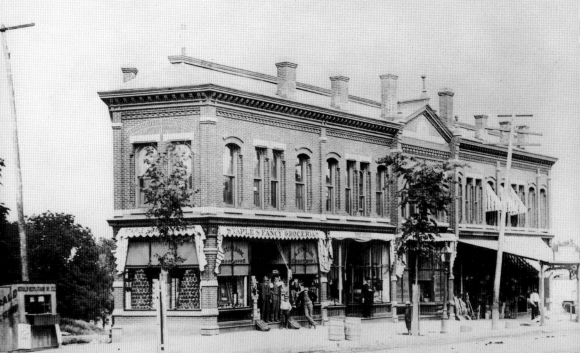

Hooe Brothers

About 1870, Charles, William, and Rosher Hooe migrated from Virginia. They and their families worked at anything they could do to get ahead. They built a newsstand at the corner of Bloomfield and Glenridge Avenues. This was the town's first African American business. The family ran it until around 1910. The photograph shows the stand and the building at the corner. Another structure now stands on this spot.

CHAPTER THREE

Business and Philanthropy

In the early 20th century, Montclair had the third-highest number of millionaires per capita in the country. New York and Morristown surpassed it, but Montclair was home to many wealthy and influential families. Montclair may not have the pull it once had, but a large number of businesspeople still live here. Many commute to New York, and others have local businesses.

Montclair has a longstanding connection to Chemical Bank. Joseph A. Bower was president of Chemical National Bank, and became an executive vice president of the new bank when Chemical National merged with Citizens National Trust, forming Chemical Bank & Trust. Joseph and Emma lived at 136 Upper Mountain Avenue. The new bank was headed by Percy Johnston, who also lived in Montclair. Percy guided the bank until 1946, when Montclairian Harold Helm took over. Percy and Belle Johnston lived in a mansion called Rose Brae on Pleasant Avenue. It was the place to be seen. Montclair's upper crust breathlessly waited for an invitation to a party at Rose Brae, which is now a nursery school. Robert McNeill, of 52 Wayside Place, was chairman of New York Manufacturers Hanover Bank. "Manny Hanny" later became part of Chemical Bank, which assumed the name J.P. Morgan Chase after acquiring those organizations.

Montclair businesspeople are generous. John and Emoral Rudd, who sold real estate and had a few other concerns, donated to the Red Cross and the YWCA. John had a passion for contributing to medical science, and became the first African American trustee on the Community Hospital Board. John Cali also had a successful career in real estate. He and his wife, Rose, have given in other ways. Cali always had a love of music, so it was natural for them to contribute to a school for music at Montclair State University. William Geyer, who played football for Bloomfield High, Colgate University, and the Chicago Bears, and his wife, Helen, lived on Afterglow Avenue. He had been president of Scientific Glass Apparatus in Bloomfield. They devoted time and money to the Montclair YMCA. He was president of the Heritage Club, which controls the YMCA's endowments. A YMCA family center that recently opened on Glenridge Avenue is named for them.

Even Montclairians who are not wealthy find ways to devote their time to worthy causes. Charles Heydt was a stenographer for John D. Rockefeller. The industrialist, who had a knack for picking capable assistants, made Heydt responsible for Rockefeller's real estate holdings. Heydt was a founder of the Rockefeller Foundation. Raymond Fosdick, brother of Rev. Harry Emerson Fosdick, was a lawyer who lived on Union Street. He likewise attracted the attention of John D. Rockefeller Jr., who gave Fosdick several important assignments, then made him president of the Rockefeller Foundation. Fosdick served as president from 1936 to 1948.

William Lanman Bull came to Montclair and formed a partnership with Edward Sweet. They sold government securities, and Bull later became the president of the New York Stock Exchange. Ellis Earle was the chairman of the Nipissing Mining Corporation. He and his wife, Adelaide, built a mansion at 10 Edgewood Terrace with a breathtaking view of the city. The view improved when the Empire State Building went up. Earle, along with former governor Alfred E. Smith and others, arranged financing for that building. Bob Gaudio, keyboard player, singer, and composer for the Four Seasons, later lived in

the same house for a few years in the 1970s. Frank Sinatra visited Gaudio at the mansion while Gaudio composed for him.

Although Huntington Hartford, the founder of A&P food stores, did not live in Montclair, his son, George, who took over the chain, did. Clarence Birdseye, who developed ways to flash freeze food, went to Montclair High School. T. Albeus Adams and his wife, Kathleen, lived at 24 Prospect Terrace. Adams and his brother started a successful beef distribution company. The Swift Company bought their business, and the brothers opened a chain of refrigerated warehouses for food in the Jersey City area. Adams, who was always looking for better ways to get his products into Manhattan, advocated an interstate tunnel. He became president of the Interstate Bridge & Tunnel Commission, and is sometimes referred to as the "Father of the Holland Tunnel." Another "food" man was Edward Wesson, who developed Wesson Oil. He and his wife, Mary, lived at 111 South Mountain Avenue.

G. Ellsworth Huggins financed textile businesses. A graduate of the University of Missouri, he endowed his alma mater with a scholarship fund. He and his wife, Marion, lived at 31 Eagle Rock Way. Another businessman who was closely associated with schools was William Kingsley, chairman of US Trust, a massive holding company. Kingsley maintained a lifelong relationship with New York University, from which he graduated. He performed many functions at the university over the years, including serving as treasurer. Kingsley was also treasurer of the New York Salvation Army, president of the board at Union Theological Seminary, and was active in the YMCA in New York. He and his second wife, Elizabeth, lived at 158 Gates Avenue. In addition, Kingsley, without fanfare, mentored ex-convicts, giving them a second chance at life.

Montclair has been home to a few oilmen. Everrette DeGolyer was one of the first geologists to search for oil with sound waves. He became president of the Amerada Corporation, which later merged with Hess Oil. He built an elegant home, called Highwall, on Lloyd Road. Charles Hamilton was vice president of the Gulf Oil Corporation and chairman of the Montclair State College (now University) Development Fund. Charles and Lucile lived at 210 Highland Avenue. John Blondel, who lived with his wife, Kathleen, at 169 Midland Avenue, delivered coal and oil to homes. H. Russ Van Vleck invented a safe way to meter oil into trucks, which then delivered it to homes in Montclair and surrounding area. He and his wife, Mary, lived at 333 Park Street.

The town has had its cattlemen, too. Swen Swenson, who lived at 88 Upper Mountain Avenue with his wife, Jean, inherited his grandfather's 275,000-acre cattle ranch in Texas. His father, Eric, used the ranch as a holding company and became a banker. Eric was the chairman of the board at Citibank, and Swen was a director. Although he was better known as a real estate agent, Frank Ward auctioned off cattle at his sister's boardinghouse, The Walnut Mansion, at 74 Pleasant Avenue.

Edwin McBrier, who lived with his wife, Carrie, at 203 South Mountain Avenue, started a five-and-ten store in Buffalo with his cousin. That store grew into a chain with 112 locations. The chain was merged with other chains, founded by his other cousins, into F.W. Woolworths. And no history of Montclair would be complete unless it included the name of Benjamin Moore, the paint magnate. He moved his base of operations from Brooklyn to Newark and lived at 354 Upper Mountain Avenue with his wife, Emma.

Starr J. Murphy

Starr Murphy was born to the Rev. Elijah and Harriet Murphy. His father became pastor of the Port Society Church in New York, which ministered to seamen. Murphy's parents moved to Montclair, and Starr studied law at Columbia. He worked for Chamberlin, Carter & Hornblower until he started his own firm. He married Julia Doubleday and built a house at 24 Prospect Terrace (below). In 1904, Murphy was hired to review documents pertaining to new buildings at Harvard. The buildings were funded by the General Education Board, one of John D. Rockefeller's earliest charities. Rockefeller was so impressed with Murphy's review that he asked him to work for Standard Oil. Murphy became a trustee of the General Education Board. In 1910, at Rockefeller's request, he and two other Montclairians, Frederick Gates and Charles Heydt, established the Rockefeller Foundation.

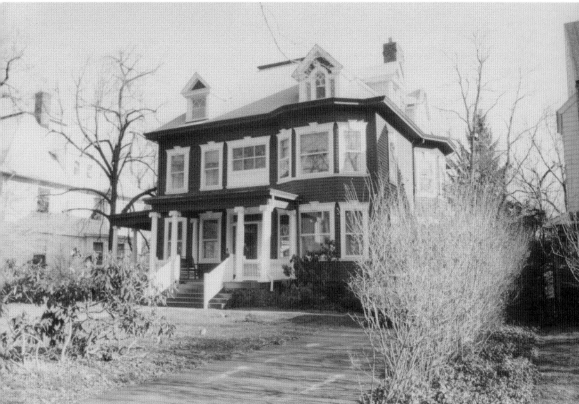

Frederick Gates
The Rev. Frederick Gates, a Baptist minister who met John D. Rockefeller in 1889, and his wife, Emma, built this house at 66 South Mountain Avenue in 1904. Gates was involved with Rockefeller's charity, the American Baptist Education Society, and managed Rockefeller's philanthropic activities. Gates and Montclairians Starr J. Murphy and Charles Heydt organized the Rockefeller Foundation. This building was later home to the African American religious leader Manuel "Sweet Daddy" Grace.

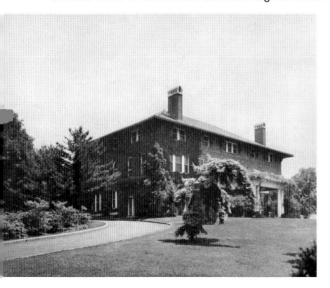

Van Vleck House and Gardens
In 1868, Joseph Van Vleck Sr. bought Josiah Crane's farm. He lived in the farmhouse while building a house (since demolished) where Van Vleck Gardens are now. His son, Joseph, designed this house on the lot for his brother, Charles. Joseph Jr.'s son, Howard, and his wife, Harriet, lived here later. Howard assembled the wonderful collection of plants and trees that make up the gardens now.

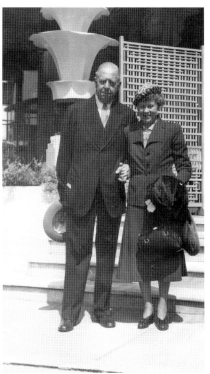

John and Florence Schumann

Florence's father was a founder of IBM. John's career peaked when he became president of the General Motors Acceptance Corporation. They were committed to public welfare and founded the Florence and John Schumann Foundation in 1961, which later became the Schumann Fund. They donated generously to Mountainside Hospital and Montclair Kimberly Academy. The couple lived at 109 Llewellyn Road. (Photograph by Ella Barnett.)

James Jarvie

James Jarvie, president of Arbuckle Coffee and director of many banks, lived in this home with his sister. Their house on Upper Mountain Avenue (pictured) burned down in the 1930s. James gave his sister $1 million to relocate when he married. He built an addition to Westminster Church in Bloomfield, and it became the Bloomfield library. It is now part of the theater at Bloomfield College. Jarvie willed $15 million to the Jarvie Commonweal to help the aged.

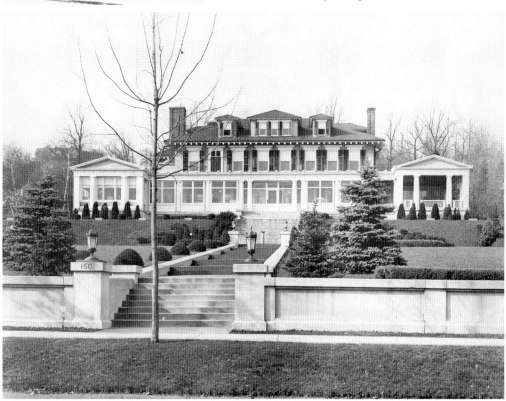

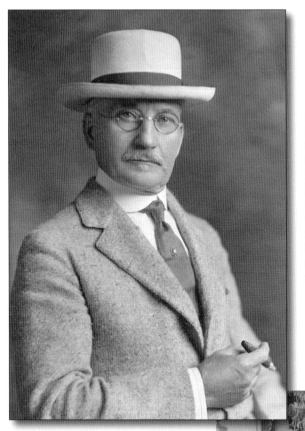

David Mills

Mills started the Rajah Spark Plug Company. The connection between spark plugs and their wires is still known as the rajah connector. He became president of the Frank A. Reeve automobile dealership on Glenridge Avenue. It is said that when he gave money to Mountainside Hospital for a nursing school, he made the trustees apply for a mortgage from him. He marked it "Paid" at the signing!

Ella Mills

Ella Mills shared her husband, David's, concern for the public good. The Mills formed a charitable organization called the Davella Mills Foundation, "Davella" being a contraction of their names, David and Ella. They funded parkland, scout camps, hospitals, and education, and provided the money to build the Social Services building on South Fullerton Avenue. She died in 1931, 23 years before her husband passed on.

Paul Volcker

Volcker went to Princeton and received a master's degree in political economy and government from Harvard. He took a leave of absence to study as a Rotary Fellow at the London School of Economics, then spent a couple of summers as a research assistant at the Federal Reserve Bank in New York. Following this, he went to Washington to work on the technical staff at the treasury department. He and his first wife, Barbara, moved to 509 Park Street in Montclair when he started to work for Chase Manhattan Bank in New York. Volcker bounced back and forth between Chase and the treasury department. During his first stint at Chase, he did research on financial markets and institutions. In 1962, Volcker returned to treasury, where he worked his way up to deputy undersecretary for monetary affairs. He went back to Chase Manhattan as vice president and director of forward planning, where he had the responsibility of planning the overall management of the bank's assets and resources. In 1969, he was called back to the treasury department as undersecretary for international monetary affairs. In 1974, he left to become president of the Federal Reserve Bank. In 1979, Pres. Jimmy Carter appointed him chairman of the Federal Reserve, and he was reappointed by Pres. Ronald Reagan. Volcker was chairman of the Fed until 1983. He then went into the private sector as chairman of Wolfensohn & Co., an investment firm.

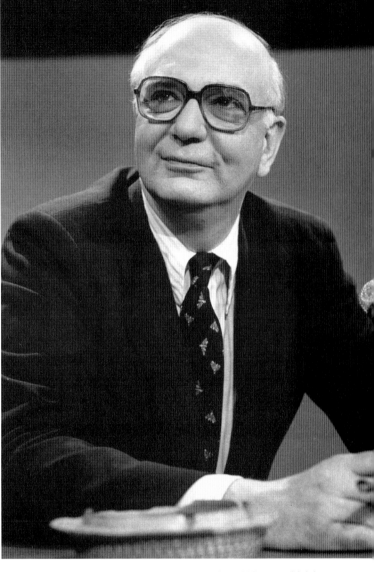

Volcker has been extraordinarily active since he left government service. He continues to be in demand as a consultant and as a member of many corporate boards. The highlights of his post-government career include his part in the famous Volcker Commission, which investigated the accounts of Jewish Holocaust victims that were still being held by Swiss banks. He was asked by the United Nations to investigate possible corruption in the Iraqi oil-for-food program. He became critical of deposit banks taking part in high-risk investments, and his pronouncements on this matter have been called the Volcker Rule. He warned of possible bank failures before the collapse of many institutions in 2008. He joined President Obama's Economic Recovery Board. He still believes that banks should stay away from hedge funds and other financial innovations. He often likes to say, "The only useful innovation that banks have come up with is the ATM." (Courtesy/Photograph AP Photo/Suzanne Vlamis.)

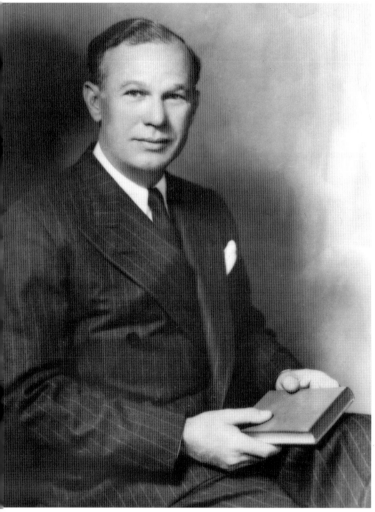

Elmer Bobst

Elmer and Mary Elizabeth Bobst moved to Montclair in 1928. In 1935, they moved into Everett DeGolyer's mansion at 120 Lloyd Road, known as Highwall. Bobst started as a salesman for Hoffman–La Roche and ended up as president. He then went to the company that became Warner Lambert, rising to the position of chairman. He was a prodigious fundraiser, raising hundreds of millions of dollars for the American Cancer Society.

Applegate Farm

This farm has been a dairy farm or an ice-cream stand since Abraham and Auley Sigler owned it in 1823. In 1902, Julian Tinkham bought the farm and gave it its name. He hired Frank Oliver to manage it. Later, Oliver's son-in-law, Donald Littlefield, took over, focusing on ice cream. Betty Vhay became the owner in 1980, and then ownership transferred to her nephew, Jason Street. It is a New Jersey institution.

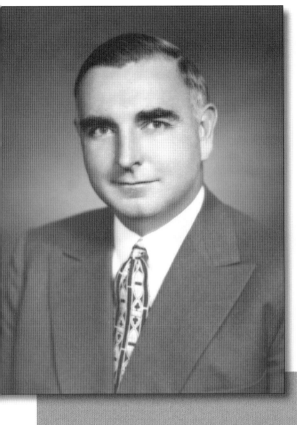

Harold Helm
Helm started at Chemical Bank as a cashier after graduating from Princeton. He eventually became chairman and oversaw the merger with the Corn Exchange Trust in 1954 and with New York Trust in 1959. He was a lifelong supporter of Princeton University, and became a trustee of the Davella Mills Foundation in 1947. He and his wife, Mary, lived at 45 Lloyd Road for many years. (Photograph by Pach Brothers.)

Hampton House
Carl Fisch started Hampton House furniture store in 1947, and the family still runs the business today. Looking at the four-story building, people often wondered about the store's slogan, "Seven floors of fine furniture," until they realized that it included three floors of the attached building. Hampton House was the only business that underwent a renovation, of a part of the building, when the town commission called for modernization. (Photograph by Leslie Love.)

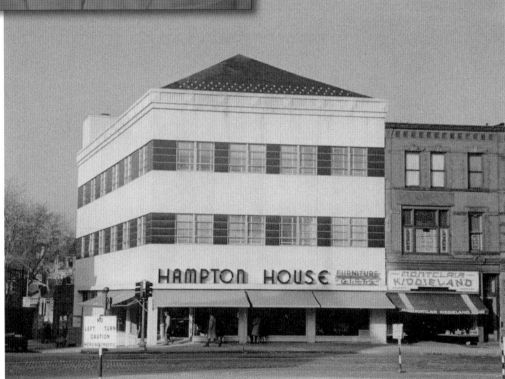

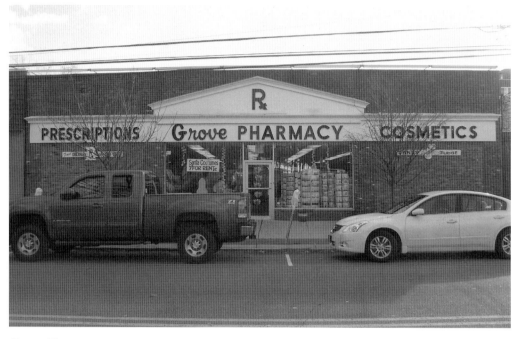

Grove Pharmacy

In 1927, Irving Hollander worked in a drugstore at the corner of Grove and Walnut Streets. He eventually became owner, and in 1941, he and his brother-in-law, Emanuel Lorber, moved a few doors north to an old A&P. In 1962, Hollander retired. His son, Larry, joined his uncle. In 1968, Larry bought the building. Larry, an avid runner who has competed in marathons, recently sold the pharmacy. (Photograph by Mike Farrelly.)

Keil's Pharmacy

Herman Keil started the pharmacy in 1933 and was succeeded in the business by his son, Stuart, and his grandson, Andrew. Bob Doremus, a Vietnam War POW who was held for years at the infamous "Hanoi Hilton," was employed there. The store was remodeled in 1959, 1967, 1981, 1987, 1993, and 2000. The business lovingly records its history on top of an old bottle rack behind the counter. (Photograph by Mike Farrelly.)

CHAPTER FOUR

Montclair Art Colony

From 1865 to 1909, several well-known artists settled in Montclair, forming the Montclair Art Colony. These artists, the most prominent of whom was George Inness Sr., were the first of many who have made Montclair their home. Today, Montclair has a thriving art community and several art galleries.

In the 1860s, two English illustrators, Harry Fenn and Charles Parsons, arrived in Montclair. Fenn, a pioneer in landscape illustrations for books and magazines, came to town around 1865. From 1870 to 1872, he worked for the D. Appleton Company, creating illustrations for *Picturesque America*, which featured landscape scenes from around the United States. After the success of this publication, the company sent Fenn to create illustrations for *Picturesque Europe* and *Picturesque Palestine, Sinai, and Egypt*. He illustrated books by several well-known authors, including John Greenleaf Whittier, Harriet Beecher Stowe, William Cullen Bryant, Alfred Tennyson, Henry Wadsworth Longfellow, and Oliver Wendell Holmes. Fellow landscape illustrator Charles Parsons arrived in Montclair a few years later. He was the director of the art department at *Harpers* from 1863 to 1889 and is credited with being one of the first editors to use illustrations in magazines. In addition, he created several drawings that were produced by the famous Currier and Ives.

Another group of artists came to Montclair in the 1880s. George Inness Sr. was one of the most prominent landscape painters of his day. His presence in Montclair attracted other Montclair Art Colony artists to settle in the town. His son, George Inness Jr., was also a landscape painter. Jonathan Scott Hartley, Inness Sr.'s son-in-law, was a well-known sculptor. His best-known piece is *Whirlwind*, but he was also known for his portraits. Another artist who came in the 1880s was Joseph King, a portrait etcher.

The 1890s brought another wave of artists. Emilie and Walter Greenough came in 1890. They were involved in a variety of artistic endeavors, including stained-glass window designs, portrait paintings, pageants, and photography. In 1893, Thomas Manley, a landscape etcher and painter, and Douglas Volk, a portrait painter and art educator, arrived. A few years later, Lawrence Earle, Thomas Ball, and his son-in-law, William Couper, moved to Montclair. Earle, a portrait painter, produced two murals for the 1893 World's Columbian Exposition in Chicago. Ball and Couper were well-known portrait sculptors. Manfred Trautschold, another artist, arrived, as did Frederick Waugh, a renowned marine painter. He was the last Art Colony artist to arrive in Montclair, around 1907–1908.

Other artists who were affiliated with the Art Colony but did not live in Montclair were George Bellows, who spent a few summers in Montclair and married a local woman; Frederick Ballard Williams, who lived in Glen Ridge but was active in the Montclair Art Museum; Charles Warren Eaton, who lived in Bloomfield; and Joseph Jefferson.

Unlike many other art colonies, which operated on a seasonal basis, Montclair's was a year-round community. The artists, therefore, became involved in the town.

One of the attractions of Montclair was its close proximity to New York City. Initially, many artists maintained studios in New York as well as in Montclair. The easy commute made it possible for artists to maintain a professional presence in the New York art scene. Some of the artists, including Jonathan

Scott Hartley and Douglas Volk, were involved as members or teachers of the Art Students League, Salmagundi Club, and Cooper Union Institute.

At the same time, Montclair offered these artists a small town in which to raise their families. Many developed professional and personal relationships with each other, attending social events together. Many of the artists' wives and children had musical and artistic talents. Musical performances were part of the group's entertainments. Another form of entertainment was artistic tableaux, which the Greenough family enjoyed organizing. Some of the tableaux were scenes of famous paintings. In 1897–1898, Walter Greenough organized two tableaux programs as fundraising events for Union Congregational Church. He recruited neighbors and other members of the Art Colony to participate. Starting in 1894, the artists participated in several art loan exhibitions at the Montclair Club on Church Street.

Some artists became involved in civic affairs. George Inness Jr. was particularly active in town affairs, joining the volunteer fire department and other organizations.

The most lasting legacy of the Montclair Art Colony was the founding of the Montclair Art Museum. Many of the Montclair Art Colony artists, including Harry Fenn, Thomas Manley, William Couper, and Frederick Waugh, were involved in the museum's early years. The Montclair Art Association was formed in 1910 when a local art patron, William Evans, agreed to donate 36 American paintings, and his gift was matched with generous funding in the amount of $50,000 from Florence Rand Lang. In 1914, the museum, the first art museum of its kind in New Jersey, opened its doors. A wing was added in 1930, and another large addition was built in 2001. The museum has grown to become an outstanding regional American art museum with a national reputation.

In 1924, the Montclair Art Museum established an art school. Another art school was founded by Margaret Tyler Yard in 1927. She was a pioneer in teaching art to the handicapped. The two art schools have merged and still operate as the Yard School of Art at the museum.

These Art Colony artists were the first of many to settle in Montclair. Artists have continued to be attracted to Montclair's proximity to New York's art scene. In addition, affordable art studio space is available in Montclair and the nearby towns of Bloomfield and West Orange. Montclair State University also brings professional artists into the community.

In 1990, the Montclair Arts and Cultural Alliance was formed to nurture partnerships between artists and businesses. In 1996, an arts census determined that 125 artists were living in Montclair.

In 1997, the Montclair Art Museum presented an exhibit on the Montclair Art Colony and featured 28 contemporary artists living in Montclair at that time. The contemporary artists included expressionist painter Miriam Beerman, illustrator Lynne Buschman, sculptor Yvonne Doboney, and printmaker Catherine Le Cleire. The exhibition encouraged museum-goers to visit the many galleries in town. Following this exhibition, Studio Montclair was formed to promote artists in the community and to provide opportunities for artists to exhibit their works.

One of the better-known artists of the 20th century in Montclair was Don Miller, who came to town at a young age from Jamaica. A renowned illustrator specializing in African American and African themes, Miller, in 1986, unveiled his acclaimed *King Mural* at the Martin Luther King Jr. Memorial Library in Washington, DC.

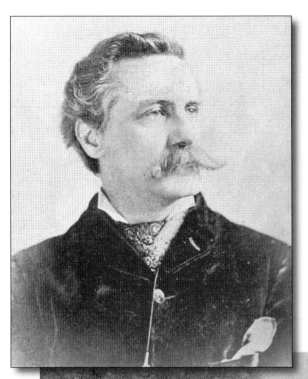

Harry Fenn

Best known for his illustrations for John Greenleaf Whittier's *Snowbound* and *Ballads of New England* and the Appleton Company's *Picturesque America*, English-born Harry Fenn moved to Montclair around 1865. After living in Europe and the Middle East from 1873 to 1881, he returned to Montclair in 1884–1885, moving into the house shown below. Called The Cedars, the home stood on Upper Mountain Avenue and was later moved to North Mountain Avenue. Fenn was known for the accurate representation of details in his work, and this made him an artist in demand for both landscape and architectural drawings. He was one of the founders of the American Watercolor Society. Among his friends were well-known artists and writers. He was described by local dentist Samuel Watkins in his memoirs as "a genial gentleman and a joy to all who knew him." (Below, courtesy of Montclair Historical Society.)

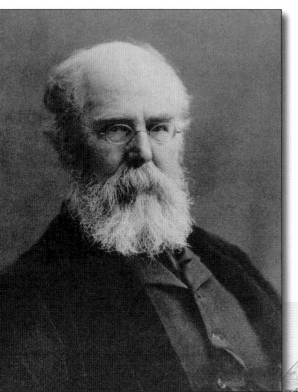

Charles Parsons

English-born illustrator Charles Parsons lived in Montclair from around 1868 to 1885. He immigrated to the United States when he was nine. At the age of 15, he was an apprentice at George Endicott, eventually becoming the head of the lithographic department and a partner of the firm. While at Endicott, he created several illustrations for Currier and Ives. In 1863, he became the art director for *Harpers*, where he worked with many prominent artists of the day. After retiring in 1889, he worked primarily with watercolors. He had a charming personality and knew how to find the right artists for the job. His home on South Mountain Avenue (below) was later occupied by Ballington and Maud Booth.

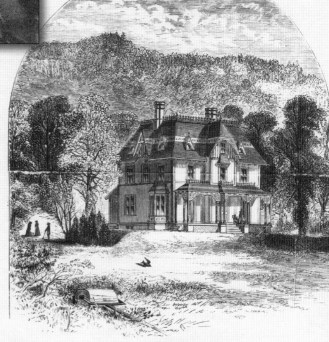

RESIDENCE OF C. PARSONS, MONTCLAIR, N. J.

New-York, May 1st, 1869.

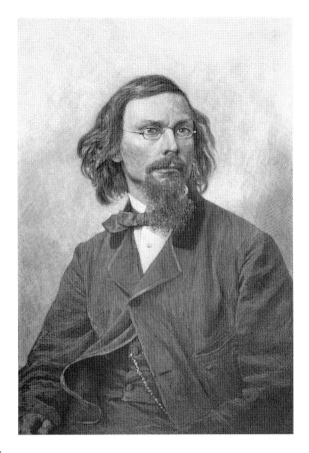

George Inness Sr.

George Inness was born in Newburgh, New York. His parents, John and Clarissa Inness, moved the family to Newark in 1830. Inness did not fit in well at school. He had a vivid imagination and bombarded his teachers with all kinds of fantastic questions. He was taken out of school at the age of 14.

After a short, unhappy stint in the grocery business, he was briefly apprenticed to John Jesse Barker, a landscape painter in Newark. In his late teens, Inness worked as an engraver in New York, which brought him into contact with the French landscape painter Regis Gignoux. He studied with Gignoux for about a month, and, other than a few classes at the National Academy of Design, that was the extent of his formal art training.

Inness found a sponsor and made his first trip to Europe in 1851, where he came under the influence of the Barbizon School of landscape painters. This school was marked by loose brush strokes and darker moods. His interest in the mystical teachings of Emanuel Swedenborg comes through in his paintings, giving them a spiritual quality. His genuine awe of nature is vividly apparent in his work. He was regarded as the foremost landscape painter of his day. His stature drew other artists to Montclair.

Inness was consumed by his art. He had little concern for his appearance, and would often forget to eat. He worked with an intensity that astonished friends and visitors. He needed someone to look after his "worldly" affairs. Inness's first wife, Delia, died only a few months after they were married. It was his second wife, Elizabeth, who nurtured him and enabled him to devote himself fully to painting. Inness started spending the summers in Montclair in 1878. In 1885, he moved to town. He bought a place called The Pines on Grove Street and renovated the barn for use as a studio for himself and his son-in-law. The house and studio were later razed to make way for Columbus Avenue. On August 3, 1894, while in Scotland, he went for a walk to view a beautiful sunset. He exclaimed, "My God! Oh, how beautiful!" and fell to the ground. He died a few hours later. (Drawing by T. Johnson.)

George Inness Jr.

Born in Paris in 1854, George Inness Jr. was a landscape painter. He married Julia, the daughter of publisher Roswell Smith, and his father-in-law built the couple a beautiful home, Roswell Manor, on Walnut Crescent. The house, later owned by art collector Walter Evans, was used as a nurses' home for Mountainside Hospital. Inness received some notice for his animal and landscape paintings, but he never achieved the stature of his father. In 1894, claiming to have a vision from his recently deceased father, he suddenly destroyed all of his paintings and started producing religious art, for which he received awards and praise. Unlike his father, he was very active in Montclair affairs, including the Montclair Fire Department, Children's Home, Montclair Athletic Club, and Montclair Equestrian Club. (Left, photograph by Grey Photo.)

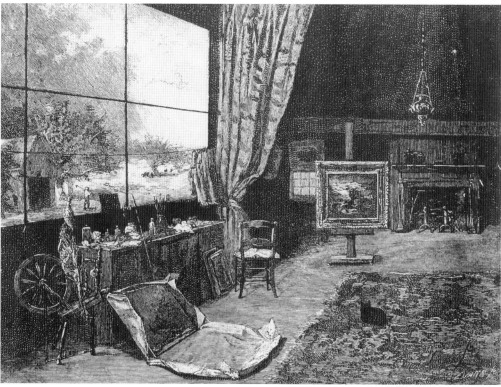

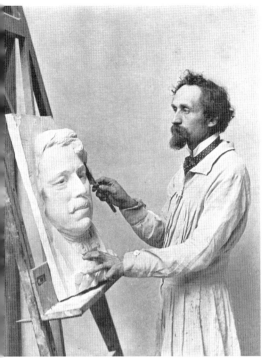

Jonathan Scott Hartley

Jonathan Scott Hartley married not one but two daughters of George Inness Sr. His first wife, Rosa, died in childbirth, and he later married her sister, Helen. Hartley's home (below) was on the Inness "Pines" property. The two homes were connected by a second-floor art gallery. Hartley studied at the Royal Academy of Art in London and the Royal Art School in Berlin. Trained as a stonecutter, he sculpted nudes and portraits. One of his best-known portraits is *John Ericsson* in Battery Park, New York City. He was one of the founders of the Art Students League and the Salmagundi Club in New York, and was an instructor of anatomy at the Art Students League.

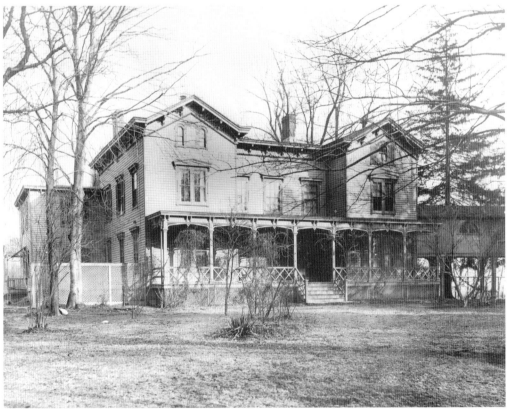

Emilie and Walter Greenough

The Greenoughs moved to Montclair in 1890. The couple met at the John La Farge Studio in New York, where they designed several stained-glass windows for the firm. In the above photograph, the couple is seen with their four children, Walter, Emilie, Margaret, and Kathryn, and unidentified guests. Walter, a book illustrator and painter, won an award for his painting *On Guard* at an exposition in Paris. He was also interested in color photography. At the age of 13, Emilie Koehler won a poster contest and scholarship to the Philadelphia School of Design. Later, she studied at Cooper Union. After her husband's death from pneumonia at the age of 41 in 1898, Emilie continued to support her four young children through her stained-glass window designs and portrait and landscape paintings, as seen in the photograph at right. (Both courtesy of the Stehli-Knoerzer family.)

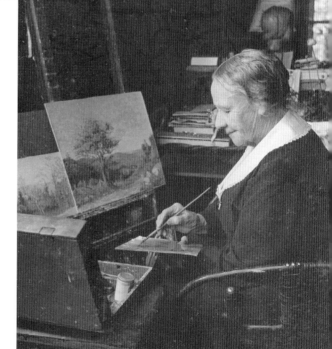

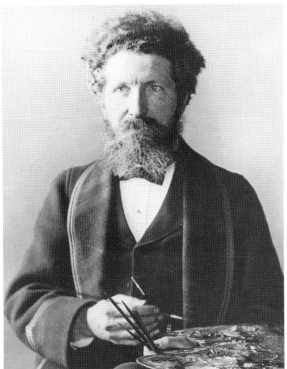

Joseph King

Joseph King moved to Montclair in 1888. He studied at the Art Students League and under Jean Leon Gerome at L'Ecole des Beaux Arts in Paris for five years. He was considered one of the best portrait etchers in the United States. Some of his portraits include John Hay, Chief Justice Melville Fuller, and Pres. Theodore Roosevelt. He lived on Valley Road. (Photograph by W.H. Crocker.)

Thomas Manley

Thomas Manley came to Montclair in 1893. A self-taught artist, Manley experimented with a variety of art media, including etchings, miniatures on ivory, murals painted on raw linen, and landscapes. He was known for making and mixing his own paints and crayons. In 1917, he rented a carriage house for his studio on Dike's Lane. He was active with the Montclair Art Museum.

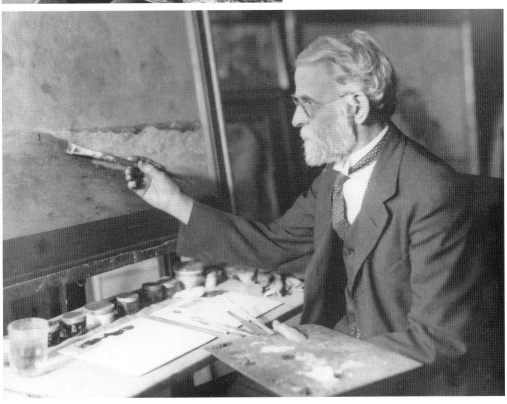

Douglas Volk

Douglas Volk lived in Montclair from 1893 to 1899. While his father, Leonard Volk, a sculptor, was creating a bust of Abraham Lincoln, young Douglas sat on Lincoln's knee. Douglas, a portrait and figure painter, was an art educator at Cooper Union, the Art Students League, the National Academy of Design, and the Minneapolis School of Fine Arts. His son, Gerome, is the model for this painting.

Lawrence Earle

Earle moved to Montclair in 1895. He was known for his character portraits of old men and for two murals displayed at the World's Columbian Exposition in 1893. Frederick Church said, "He is one of the best watercolor painters we have. . . . He is very versatile, understands thoroughly the use of all mediums, paints a good portrait . . . and is a first-class landscape artist." (Whittemore, *History of Montclair Township*, p. 280.)

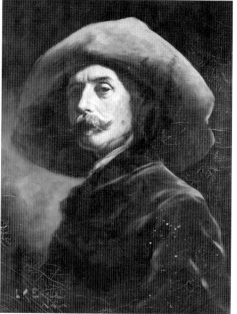

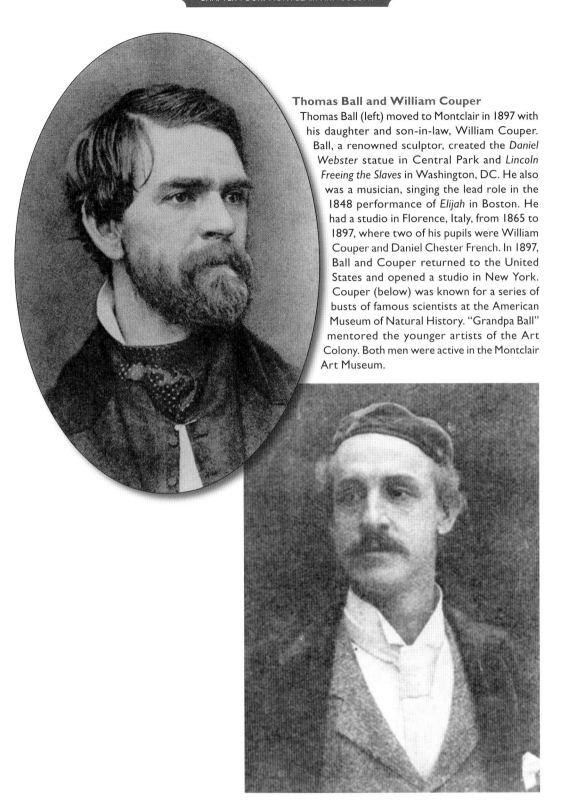

Thomas Ball and William Couper
Thomas Ball (left) moved to Montclair in 1897 with his daughter and son-in-law, William Couper. Ball, a renowned sculptor, created the *Daniel Webster* statue in Central Park and *Lincoln Freeing the Slaves* in Washington, DC. He also was a musician, singing the lead role in the 1848 performance of *Elijah* in Boston. He had a studio in Florence, Italy, from 1865 to 1897, where two of his pupils were William Couper and Daniel Chester French. In 1897, Ball and Couper returned to the United States and opened a studio in New York. Couper (below) was known for a series of busts of famous scientists at the American Museum of Natural History. "Grandpa Ball" mentored the younger artists of the Art Colony. Both men were active in the Montclair Art Museum.

Frederick Waugh

Renowned marine painter Frederick Waugh, son of Samuel Waugh, moved to Montclair around 1907–1908. After training with Thomas Eakins at the Pennsylvania Academy, he spent several years living in Paris, Cornwall, and London. When he moved to Montclair, Waugh took over George Inness Jr.'s studio on Walnut Crescent. He became active in the Montclair Art Museum, serving as a trustee. His wife and both of his children were artists.

George Bellows

George Bellows met his future wife, a Montclair resident, in 1904 and made several visits to the town. A semiprofessional baseball player, he played for the team at the Montclair Athletic Club. Bellows was noted for painting scenes from everyday life in New York and for his prizefighters series. In 1922, he joined the art colony in Woodstock, New York. This painting is titled *Emma in Black Pencil*.

Florence Rand Lang

Florence Rand Lang (above) was the daughter of Jasper Rand, cofounder of Ingersoll & Rand. When William Evans offered to donate a collection of American art to form a museum, Lang pledged $50,000 toward the building. When the museum (below), designed by Albert Randolph Ross, opened in 1914, it was the first of its kind in the state of New Jersey. In 1931, Lang gave additional money for a library and a wing to house her Rand North American Indian Collection, which is still a cornerstone of the museum's holdings. Lang also was a patroness of the arts in Nantucket, Massachusetts, and Westfield, New Jersey. Additional money was given to the high school's amphitheater and to Rand Park. (Above, photograph by Evans.)

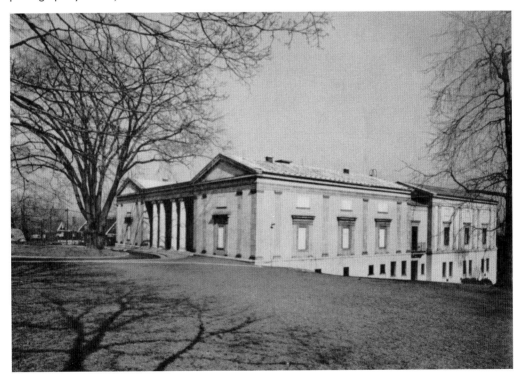

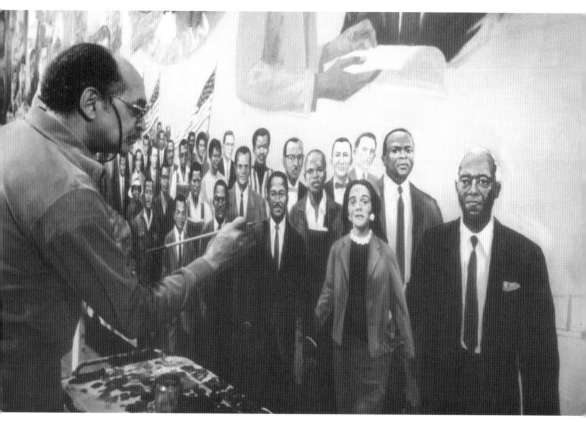

Don Miller

Born in Jamaica in 1923, Don Miller immigrated to Montclair with his parents when he was an infant. During World War II, he was stationed on Adak Island. While there, he created cartoons and illustrations for the station newsletter, which was edited by mystery writer Dashiell Hammett. After the war, Miller studied art at Cooper Union, graduating in 1949. He worked as a commercial artist at Chernow Company, Black Star, and Gorham in New York. Unhappy creating commercial art, he became a freelance artist starting in 1954. In 1962, while attending a meeting at his son's school, he noticed that the books did not feature any illustrations of African Americans or people of other ethnic groups. He decided to contact various educational publishers regarding producing books with more diverse illustrations. After receiving positive responses from Silver Burdett and MacMillan, he created illustrations for several of their educational books. In the 1970s he traveled to Africa, where he studied African art and painted local scenes.

He is shown here with his best-known work, the *King Mural* at the Martin Luther King Jr. Memorial Library in Washington, DC. When Miller heard that there was a movement to create a federal holiday in King's honor, he wanted to create a visual tribute to King. He contacted the trustees of the public library in Washington, DC, with his proposal to create a mural. The commission was granted in 1984. The 56-foot-long mural depicts scenes from Dr. King's life, from his birth in Atlanta to his death in Memphis. The mural includes 10 portraits of King and 98 other people and events from the civil rights movement, including the Montgomery bus boycott, the Birmingham church bombing, and the 1963 March on Washington. Other civil right activities, such as voter registration drives and protests, are depicted. The mural also shows burned-out churches and scenes from the Vietnam War. Other murdered activists are depicted, including Medgar Evers, Michael Schwerner, James Chaney, Andrew Goodman, Jimmy Lee Jackson, Viola Liuzzo, and the Rev. James Reeb. Several thousand people attended the dedication of the mural on the first Martin Luther King Jr. Day in 1986. (Photograph by David Henderson; courtesy of Newark Museum.)

CHAPTER FIVE

Arts and Entertainment

Montclair got talent in spades! Montclair has been a regional cultural mecca, boasting one of the first regional art museums in New Jersey (Montclair Art Museum), one of the oldest community theaters (Montclair Dramatic Club), one of the oldest musical theaters (Montclair Operetta Club), and the original home of the New Jersey Symphony. Montclair's proximity to New York City allows talented people to have access to the cultural hub that is New York, but at the same time to live in a smaller, suburban community. The list of talented Montclair residents could fill an entire book; unfortunately, only a few can be highlighted here.

Montclair has seen many talented musicians, representing all musical genres, from classical to jazz. In the 19th century, music was a popular form of entertainment. An early amateur group was the Ladies Vocal Music Club, formed in 1885. A well-known early 19th century musician was William Bradbury, who wrote several hymns for children, including *Jesus Loves Me*.

In 1901, the Musical Club of Montclair was formed by a group of amateur musicians. Mark Andrews, who emigrated from England in 1902, conducted or founded several musical groups in Montclair, including the Montclair Glee Club (1914) and the Montclair Oratorio Society (1907). Andrews also conducted the Bach Choir Festival (1905), which attracted so many people that special trains ran between Montclair and New York. More recent musical groups have been the Oratorio Society of New Jersey (1952), The Mel-O-Chords (1968), and the Montclair Community Band (1982).

Organizations featuring professional musicians have also been established. In 1916, a group of musicians called the Llewellyn Ensemble performed concerts at the home of William Dickson on Llewellyn Road. Four years later, a group from St. Luke's Episcopal Church formed the Montclair Orchestra. Members of these two groups performed a concert at the Montclair Art Museum in 1922, and they eventually became the New Jersey Symphony, now based in Newark.

In 1920, Unity Institute was formed by the Rev. Edgar Wiers of the Unitarian Church. The institute provided a variety of cultural activities, such as travel lectures, current-event forums, and drama clubs. One key component was Unity Concerts. Wiers discovered that he could attract the top classical musicians of the day between performances in New York and Philadelphia. Singers from the Metropolitan Opera Company were a mainstay of the group. Unity Concerts became independent of the church in 1982 and continued until the 2000s.

Many performers of classical music have lived in Montclair, including opera singers Dorothy Kirsten, Janet Bush-Hecht, Inez Bull, and George Shirley. Another classical artist is renowned composer and pianist George Walker, the first African American to be awarded the Pulitzer Prize in music.

Montclair has been a mecca for jazz music. In 1985, Emily Wingert founded Trumpets, a popular jazz club and restaurant. From 1986 to 2000, Bruce Tyler, jazz drummer and producer, organized the Montclair Blues and Jazz Festival, which featured local and regional musicians. Three years ago, Jazz House Kids, an organization founded in 2002 that offers educational and cultural programs for children, started up another Montclair Jazz Festival. In the 1990s and early 2000s, the town's Office for Arts and Cultural

Development sponsored jazz concerts once a month at the public library. Jazz great Oliver Lake is one of many musicians who live in Montclair.

Musicians of other genres have included folksinger Christine Lavin, pianist Robin Spielberg, ragtime composer Joseph Lamb, big band conductor and composer Phil Bennett, and Herman Hupfeld, composer of the immortal "As Time Goes By."

New York's theater district and entertainment industry have attracted many talented people to Montclair, which, at various times, has boasted five amateur or professional theaters. One of the oldest community theaters, the Montclair Dramatic Club, was founded in 1889 at the home of W.L. Guillaudeu. Starting with the first play, *Randall Thumb*, the club performed two plays each year. The organization dissolved in the late 1980s or early 1990s.

The Montclair Operetta Club, one of the oldest musical theaters, was chartered in 1925. Initially, it performed Gilbert and Sullivan exclusively, but by 1929, it expanded to other operetta composers, such as Romberg, Herbert, and Friml. In 1936, the amateur group hired its first professionals. Since then, all of the leads, directors, and choreographers have been professionals. Its first musical, *Brigadoon*, was performed in 1953.

Studio Players, another community theater, was established in 1937. It still performs a mixture of adult dramas and musicals as well as productions for children.

In 1971, Whole Theatre was formed by Academy Award winner Olympia Dukakis, her husband, Louis Zorich, and 10 other theatrical couples. The theater produced several dramatic plays each season from 1973 to 1990.

In 1992, Six Miles West Theatre was established by local artists. At first, it was housed in a rented church space. The company then leased space for several seasons in the basement of the Hinck Building in Montclair until losing its lease in 2004. It moved to the historic theater building in Bloomfield and is currently looking for a permanent home. It produces classical and contemporary plays.

Also in 1992, Luna Stage was established by Jane Mandel, wife of actor Frankie Faison. The theater initially operated in a renovated factory and, in 2001, moved to the old public service building. In 2009, the company moved to the West Orange Arts Center. It produces a variety of classical and contemporary plays each season.

Montclair has several movie theaters. The first vaudeville and silent movie theater, founded in 1913, was the Montclair Theater, at the corner of Valley Road and Bloomfield Avenue. In 1922, three silent movie theaters opened: the Wellmont, Claridge, and Bellevue. The Wellmont Theater boasted its own Frank White Orchestra, which played between movie reels. All theaters featured live acts between silent movie newsreels, cartoons, and movies. The houses all converted to the "talkies" in the late 1920s. Claridge and Bellevue are now multi-screen complexes, and Wellmont is a live entertainment venue.

Montclair also has been home to many authors and publishers. Major publishers Frederic Melcher (R.R. Bowker Inc.), Wilfred and Isaac Funk (Funk and Wagnalls), and Roswell Smith (*Century* magazine) lived in Montclair in the first half of the 20th century.

The New York publishing business and theater district has lured many fiction and nonfiction authors, poets, and playwrights to Montclair. Among these writers are Richard and Valerie Wesley, Peter Drucker, Leonard Silk, Anna Rose Wright, Madeline Tiger Bass, and Jessie Fauset Harris.

Montclair is known for its beautiful homes, from old Victorians to stately mansions. Many of these homes were built by Swedish immigrants who thrived in the building crafts trades. Architects who have worked in Montclair include Dudley Van Antwerp, Effingham North, Lloyd Berrall, Francis Nelson, and Henry Holly Hudson.

Montclair festivals include the Presby Iris Garden, African American Heritage Day and Parade, St. Sebastian Fest, and Montclair Arts in the Park. First Night, organized in 1989, was the first such New Year's Eve event in New Jersey.

Herman Hupfeld

Herman Hupfeld was born in Montclair to Charles and Fredericka Hupfeld in 1894. They lived in a large house at the corner of Park Street and Watchung Plaza. His mother was the organist at the Watchung Congregational Church for many years. When he was young, Hupfeld was sent to study the violin in Germany. He had music in his blood. He returned to Montclair and formed a jazz orchestra. During World War I, he played saxophone in the US Navy Band. He wrote the Princeton football song, "Here Comes that Tiger."

He performed as an accompanist in his early years, but later preferred instead to write songs for others. He recorded only once, with the Victor Young Orchestra in 1932. He wrote songs for *The Little Show*, a variety show featuring the top entertainers of the day, and for the *Ziegfeld Midnight Frolic*, a show that came on at night, after the *Follies*. He never wrote a complete Broadway musical, but became known as the man who could be counted on to come up with a fill-in song. His first hit was "When Yuba Plays the Rhumba on the Tuba," in 1931. That same year, he wrote a number for the play *Everybody's Welcome*. The play was a moderate success. Rudy Vallee recorded the song, but it did not chart. In 1943, the song was revived by Dooley Wilson in the film *Casablanca*. It is, of course, the immortal "As Time Goes By." Rudy Vallee admired Hupfeld, and used his song "Let's Put Out the Lights and Go To Sleep" as the signoff for Vallee's radio show.

Hupfeld never married. He enjoyed a quiet life, living with his mother, who survived him. In 1935, they hired Montclair architect C.C. Wendehack to design a house on his grandfather's property. It still stands today, at 259 Park Street. In a way, it reflects Hupfeld's character. It is quite plain on the outside, although made of very rich materials, and is elegant and ornate on the inside. For example, the living room on the second floor features painted musical notes on the wooden beams and 12-foot-high windows. Hupfeld died of a stroke at the age of 57.

Oliver Lake

Lake (right), a renowned jazz saxophonist, is a longtime resident of Montclair. He has composed for a variety of musicians and musical groups, from Lou Reed to the Brooklyn Philharmonic. In 1988, he founded Passin Thru, a nonprofit group that promotes musical understanding and appreciation. He is also a poet, painter, and performance artist. (Courtesy of Oliver Lake.)

Phil Bennett

Blind from birth, Phil Bennett was a multitalented musician and composer, playing 12 instruments and singing in five languages. He studied music at Oberlin Conservatory and Montclair State University. In 1939, he started his own orchestra, which played locally in Montclair and New York. His band played for Richard Nixon's second inauguration and performed on television and on the radio. Bennett died in 1998.

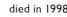

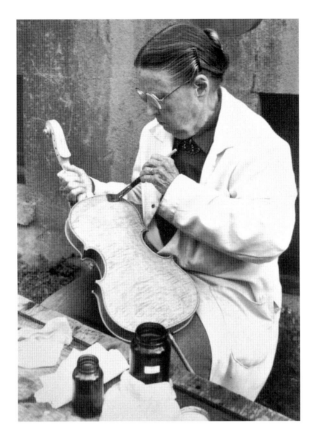

Carleen Hutchins

Born in 1911, Carleen Hutchins moved to Montclair with her parents in 1915. She played the trumpet in high school, but later decided to study the viola. Her fascination with nature and woodworking began at an early age. In 1933, she received a BA in biology from Cornell University, and earned an MA from New York University. After graduating from Cornell, Hutchins worked at the Brooklyn Botanical Gardens and taught science at a progressive private school in Brooklyn and the Brearley School in New York. While at Brearley, Hutchins was asked to join a chamber quartet. The only instrument she had was a trumpet, so she purchased a viola. Unhappy with the sound of it, she decided to build her own, using the book *Violin Making As It Was and Is* by Ed Heron Allen. Thus, she unwittingly launched what would become a new second career, building string instruments renowned for their tonal qualities. Although she studied violinmaking with Kurt Berger and Simon Sacconi, she was mostly self-taught. She took a scientific approach to making her instruments. Hutchins received Guggenheim Fellowships in 1959 and 1962. Her research was conducted with experts in the field of acoustics, most notably Frederick Saunders, a former Harvard physics professor and acoustic expert, and John Schelleng, an electronics engineer at Bell Lab. In 1963, Hutchins and her group of fellow scientists and acoustic engineers founded the Catgut Acoustical Society.

In 1957, Hutchins met Henry Brant, who asked her to build a set of seven violins. For the next several years, she worked with Saunders and others to develop eight new bowstring instruments known as the Violin Octet, which included four violins, a viola, a cello, a small bass, and a contrabass. Composers Frank Lewin, Herbert Haslam, Quincy Porter, and Brant wrote music for some or all of her instruments. In 2000, a concert featuring her octet was held at the Metropolitan Museum of Art in New York.

Hutchins made other conventional and experimental instruments, all in her workshop at her home at 112 Essex Avenue, where she had lived since a child. In 2005, Hutchins died in Wolfeboro, New Hampshire. (Courtesy of the Hutchins family.)

George Walker

Renowned classical composer and pianist George Walker moved to Montclair in 1969 after being appointed professor of music at Rutgers University–Newark. He has published over 90 classical compositions. In 1996, he became the first African American to receive the Pulitzer Prize in music, for his composition *Lilacs*. He is seen here with Katherine Dougherty, of the public library, where he performed several piano concerts.

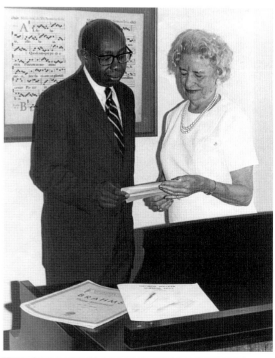

Janet Bush-Hecht

A native of Montclair, Janet Bush-Hecht was a descendent of the famous Bach family of Leipzig, Germany. When she was young, she played the violin with the Bush Family String Ensemble. Bush-Hecht performed a repertoire ranging from classical music to traditional folk tunes in concerts and on the radio. Here, she is performing at the Stage Door Canteen. (Photograph by Constance Hope Associates.)

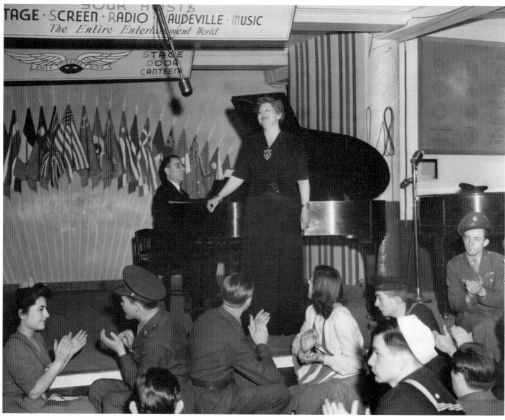

Dame Inez Bull

Bull, a concert pianist and coloratura soprano, taught music at Julliard and worked with mentally challenged children in Totowa. She was a descendent of Ole Bull, a renowned violinist who established a Norwegian colony in Pennsylvania. She was awarded the St. Olav Medal by Norwegian King Harold V in 1999 for her work in establishing the Ole Bull Museum and Music Festival in Galeton, Pennsylvania, and for serving as a goodwill ambassador.

Mark Andrews

Englishman Mark Andrews moved to Montclair in 1902 to become the organist for St. Luke's Episcopal Church. Later, he was the organist for the First Baptist and First Congregational Churches. He conducted several choir groups. Best known for his choral works for men's choirs, he wrote more than 300 compositions. Andrews (standing, second row) was the conductor of the Montclair Glee Club, shown here, for 24 years.

Unity Concerts
Founded in 1920 by the Unity (Unitarian) Church, Unity Institute offered a variety of cultural programs, including a concert series. Unity Concerts featured opera stars from the Metropolitan Opera and well-known classical musicians of the day. In 1982, the group became independent of the church, changing its name to Unity Concerts of New Jersey. Shown here is Isaac Stern at a 1992 fundraiser. (Courtesy of Unitarian Congregation.)

Montclair Dramatic Club
Organized in 1889 at the home of W.L. Guillaudeu, the Montclair Dramatic Club was one of the oldest community theaters when it dissolved in the late 1980s or early 1990s. The group performed two plays a year, usually comedies, at the Montclair Club (1889–1924), Montclair Theater (1924–1928), George Inness School (1928–1929), and Mount Hebron School (1930–1990s). Shown here is a scene from *The Philadelphia Story*. (Photograph by Frank Brown.)

Edgar Stehli

A native of France, Edgar Stehli moved to Montclair in 1894. While a student at Cornell University, he discovered acting. After graduating from Cornell in 1908 with a BA and MA in languages, he joined the Bayonne Stock Theater. Starting in 1918, he was in numerous Broadway plays, including *Hamlet*, *Arsenic and Old Lace* (originating the role of Dr. Einstein, as shown at left), and *Happy Time* (originating the role of Grandpere). Another noted role was as Dr. Huer on the *Buck Rogers Radio Show*. He married Walter and Emilie Greenough's daughter, Emilie, who was a musician and writer. Stehli often presented plays, monologues, and poetry at the Unitarian Church (below). He and his wife were avid gardeners, growing rare plants in their gardens in Montclair and Sussex County, New Jersey. (Left, photograph by Vandamm Studio, courtesy of Stehli-Knoerzer family; below, Unitarian Congregation.)

Olympia Dukakis, Louis Zorich, and The Amazing Kreskin

Born in Lowell, Massachusetts, Olympia Dukakis (center) won the Academy Award for best supporting actress for her role in *Moonstruck* in 1988. Dukakis worked for several years as a physical therapist, working with polio patients in Boston and West Virginia. Eventually, she pursued her dream of being an actress by attending the Boston University Drama School. After graduation, she became an esteemed stage actress in New York theaters and throughout the Northeast. After winning the Oscar, she worked on several other films, including *Steel Magnolias* and *Working Girl*. She met her husband, Louis Zorich (left), while working on a touring production of a Greek play.

Born in Chicago, Louis Zorich is a popular television and film actor. He attended the renowned Goodman Theatre School of Drama in Chicago. His best-known role was as Burt Buchanan in the television series *Mad About You*. He has appeared in films, including *Fiddler on the Roof* and *For Pete's Sake*. He has also appeared in numerous commercials.

In 1971, the couple, along with 10 other theatrical families from New York, founded the Whole Theatre Company. Dukakis served as the company's artistic director and later producing artistic director. Both actors appeared in several productions at the theater. Starting in 1973, Whole Theatre became a premier professional theater company in New Jersey, featuring five plays or musicals per season. Sadly, the theater filed for bankruptcy in 1990 and closed. The couple were longtime residents of Montclair.

The couple is seen here with The Amazing Kreskin, a well-known mentalist born in Montclair. In the 1970s, he had a popular show, *The Amazing World of Kreskin*, on Canadian television, which was later syndicated in the United States. In addition, he has been a popular fixture on late-night television and is known for his annual New Year's predictions. One of his popular acts is asking the audience to hide his check, after which he tries to find it. If he does not find it, he forfeits the check.

This photograph was taken at an AARP convention in Florida in 2009. (Photograph by Dan Smith; courtesy of Amazing Kreskin.)

Katherine Emery

Katherine Emery grew up in Montclair, graduating from the high school in 1924. Her love for the theater was nurtured by performing in plays produced by the Montclair Dramatic Club, Junior League, and Montclair High School. She trained at the University Players in Falmouth, Massachusetts, with stars Henry Fonda and Margaret Sullivan. She performed in several films and Broadway productions, including *Carrie Nation*, *The Children's Hour*, and *Strangers at Home*.

Frankie Faison

Longtime Montclair resident Frankie Faison has acted in several Broadway plays (*Fences*, *Of Mice and Men*, *The Iceman Cometh*), films (*Hannibal* trilogy), and television shows (*The Wire*). Faison and his wife, Jane Mandel, are founding members of the Luna Stage Company, where Faison has starred in several plays, including an African American production of *Death of a Salesman*, and where his wife is the artistic director.

Frederic Melcher

Born in Malden, Massachusetts, Frederic Melcher grew up in nearby Newton Center. In 1895, he was accepted to MIT, where he planned to study civil engineering. The economic downturn of the panic of 1893 and his lack of enthusiasm for engineering influenced Melcher to turn down college in order to seek employment. His grandfather owned some interest in a building in Boston that housed the oldest bookstore in the city, Este & Lauriat Bookstore. It was there that Melcher began his career in books. Starting in the mailroom, the charming young man who was always good with people was promoted to sales and put in charge of the children's department. He met Marguerite Fellows, a children's author and playwright, in Boston, and the couple was married in 1910. In 1913, the young family moved to Indianapolis, where Melcher was in charge of the W.K. Stewart Bookstore. When, in 1918, he learned that the editor position at *Publisher's Weekly* was available, he wrote to R.R. Bowker and requested an interview. He was hired, and the Melchers moved to Montclair. In 1934, Melcher became the president of R.R. Bowker Inc. after Bowker's death, and in 1959, he became the chairman of the board.

Melcher immersed himself in professional and civic activities. While still in Boston, he was involved with establishing the Boston Booksellers League. In New York, he was the first secretary of the American Booksellers Association, from 1918 to 1920. He was active in the American Library Association and the New York Library Association.

He had a lifelong interest in children's literature. He cofounded, with Frank Mathiews, the Boy Scouts Children's Book Week, which promoted books for boys. He founded the John Newbery (1922) and Caldecott (1937) awards, which honor the best in children's literature.

During the Hoover administration, Melcher chaired a committee to provide 500 books to the White House library. An additional 200 books were donated to the White House during the Roosevelt administration. Locally, he served on the boards of education, the library, and the art museum. He was active in the Unitarian Church.

His home at 228 Grove Street was a gathering place for authors and poets. He was a personal friend of Carl Sandburg and Robert Frost, and gave annual poetry readings at the local schools. Melcher died in 1963. (Photograph by Blackstone Studios.)

Gil Noble

Gil Noble began his career as a radio announcer and jazz pianist. Hired initially by ABC to cover the 1967 Newark riots, Noble was hired in 1968 to host (and later produce) *Like It Is*, a black weekly news and talk show, for which he earned several local Emmys.

Jessie Fauset Harris

From 1939 to 1960, Jessie Fauset Harris lived at 245 Orange Road. Harris, daughter of a Methodist minister, grew up in Philadelphia's middle-class African American community. From 1912 to 1925, she wrote for the NAACP magazine *Crisis*. She wrote four novels about the home life of middle-class African Americans: *There is Confusion*, *The Chinaberry Tree*, *Comedy American Style*, and *Plum Bun*. She also wrote poetry.

Wilfred Funk

Born in New York in 1883, Wilfred Funk, son of Isaac Funk, cofounder of Funk & Wagnalls, a major publisher of encyclopedias, dictionaries, and other reference books, moved to Montclair in 1908. Funk graduated from Princeton in 1909 and joined his father's firm, moving up the ranks to president, and serving in that position from 1925 to 1940. In 1940, he left his father's firm to start his own publishing company, Wilfred Funk Inc., which published fiction and nonfiction books.

A language expert, Funk wrote several books on the power of vocabulary, including *A More Powerful Vocabulary*, *30 Days to a More Powerful Vocabulary*, *The Way to Vocabulary Power and Culture*, and *Word Origins and Their Romantic Stories*. The popular books included entertaining stories and guidelines for better understanding the English language. In addition, he had a column, "It Pays to Increase Your Word Power," in *Reader's Digest*. Funk had an interesting attitude toward grammar—that it should not be based on rules. "Grammar is what the hearers expect, varying year from year and from group to group. Language has no fix base. Grammar is not what usage should be but what usage actually is" (*New York Times*, June 31, 1965). In 1938, he began an interesting study of dogs' understanding of the human language. Funk, a dog lover, studied his own six dogs as well as others. Through his initial study, he discovered that the average dog could understand 60 English words. His French poodle knew more than 100 words.

In addition to his own publishing company, Funk was the owner and/or editor of *Literary Digest* and Kingsway Press. He published several magazines, including *Success Today*, *Marriage*, *Your Life*, *Your Health*, *Your Personality*, and *Women Life*. Funk, a talented writer, published several volumes of poetry.

Isaac Funk also lived in Montclair, at 11 Erwin Park. Wilfred and his wife, Eleanor, and their three children lived at 16 Erwin Park. Funk, active in the Montclair community, was the founder and first president of the Montclair Community Chest and served for 17 years on the Montclair Public Library's board. He retired from his business in 1963.

Leonard Silk

In 1954, Silk was appointed the editor of *BusinessWeek* and rose in the ranks to become chairman of the editorial board in 1967. An expert in economics, Silk served on several government committees during the Eisenhower, Kennedy, and Johnson administrations. He also wrote a column for the *New York Times*. He received six Loeb Awards for distinguished business and finance journalism. His wife, Bernice Silk, was a concert pianist.

Peter Drucker

A native of Vienna, Peter Drucker was an expert in industrial management. Immigrating to the United States in 1937, he taught at Sarah Lawrence, Bennington College, and New York University Graduate School of Business Administration. He had his own management consulting firm and wrote several books on industrial management. He moved to Montclair in 1949. (Photograph by Edwin Conrad.)

Anna Rose Wright

Anna Rose Wright moved to Montclair when she was 10. At the age of 12, she won an award for an essay on a club project written for *Harper's Bazaar*. After graduating in 1914 from Vassar, she taught at Columbia University and worked at various printing firms. Her best-known book, *Room for One More*, was based on the Wrights' experience adopting children.

Pat Boyd Buckalew

Pat Boyd was a model in the 1940s and 1950s. After graduating from high school, she went to Harry Conover Studio to apply for a job. From there, she was busy modeling for fashion magazines, featured on the covers of *McCall's* and *Our Navy*. She was also an amateur actor, appearing with the Montclair Dramatic Club. (Photograph by Edward O. Kamper.)

Julia Berrall
Montclair native Julia Berrall wrote several books on floral design. Her love of flowers was inspired by her aunt's gardens. She majored in music at Vassar College and taught music in the New Rochelle schools. She worked in the exhibits departments at Newark and Montclair Art Museums. She and her husband were founders of the Montclair Historical Society. (Photograph by Henry C. Engels Studio.)

J. Lloyd Berrall
Montclair native J. Lloyd Berrall was a town planner and local architect. He worked for Shreve, Lamb, & Harmon, the firm that erected the Empire State Building. In 1935, he began to practice architecture in Montclair. During World War II, he was the town planner. In 1965, he became the first president of the Montclair Historical Society. (Photograph by James Quillen.)

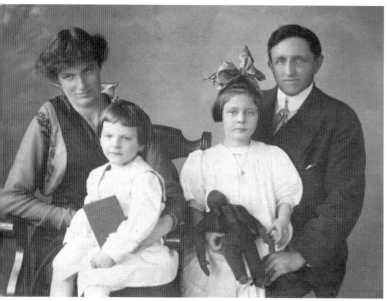

Dudley Van Antwerp
In 1880, Van Antwerp moved to Montclair, where he established his own firm in the early 1900s. Although he designed public buildings such as Watchung Congregational Church and Montclair Academy, he is known for his Craftsman designs of more than 112 houses in Montclair, Verona, and Glen Ridge. His wife, Hilda, daughter of Harry Fenn, was a painter and interior designer. (Courtesy of Montclair Historical Society.)

WOMAN'S CLUB OF UPPER MONTCLAIR

Francis Nelson
Francis Nelson moved to Montclair in 1913. After studying architecture at Columbia University and Ecole des Beaux Arts in Paris, he designed several homes, including his own at 303 Highland Avenue. However, he is best known for his public buildings, including the Woman's Club of Upper Montclair (shown here), the Bellevue Avenue Branch Library, the bell tower of St. James Episcopal Church, and the (former) Upper Montclair Post Office.

CHAPTER SIX

Science and Medicine

One of Montclair's first notable scientists was Frederick Wheeler, who invented the Wheeler Surface Condenser, which improved the efficiency of steam turbines. He invented other steam-powered devices and started the Wheeler Condenser & Engineering Company in 1890. Wheeler Condenser merged with the Power Specialty Company, owned by the Foster family, in 1927 to become today's Foster Wheeler Corporation.

W. Lincoln Hawkins, the first African American engineer to work for Bell Labs, invented flexible sheathing for telecommunications wire, which made universal telephone systems possible. He gave freely of his time to mentor minority engineering and science students. Bell Labs created an annual award, named for him, to encourage other scientists to do the same. Other telephone company wizards included Harold Osborne (mayor of Montclair from 1961 to 1964), who was the chief engineer for AT&T. He and his staff developed the system that made long-distance dialing possible. George A. Campbell's work with loading cells and wave filters allowed messages to travel farther and allowed multiple messages to be carried on the same wire. These inventions saved AT&T millions of dollars in installation costs. Campbell received the Edison Medal for his work. The medal is rarely given out, and only for significant achievements. Alexander Graham Bell and George Westinghouse were among the recipients. Campbell and his wife, Caroline, lived at 129 Bellevue Avenue. Roy W. Chestnut, of 115 Inwood Avenue, worked for Western Electric and Bell Labs. He developed circuits for radiotelephones and submarine telephones, and "carrier" circuits that allow multiple messages to be transmitted at the same time. His wife, Florence, worked in human resources for Bell Labs. She volunteered for many causes in Montclair, not the least of which was Mountainside Hospital, where she gave more than 5,000 hours over 20 years.

Henri Busignies joined IT&T in Paris before World War II. His Huff-Duff high-frequency detector allowed Allied land stations, and later ships, to pinpoint German U-boats when they made brief shortwave radio transmissions. There was a serious danger that his work would fall into German hands when they invaded France in 1940. With the aid of the Resistance, he was able get out of the country with a trunk full of devices and drawings. He went to North Africa, then to Portugal, and finally to the United States. He continued working for IT&T. His improvements to radar cleared up extraneous blips on the screen and were incorporated by air traffic controllers. He became the president of IT&T's laboratory division. He and his wife, Cecile, lived at 71 Melrose Place.

Dr. Lawrence V. Redman worked with synthetic resins at the University of Toronto and later at the University of Kansas. He started a plastics company that merged with the Bakelite Company. He was president of the American Chemical Society in 1931. He and his wife, Blossom, lived at 125 Montclair Avenue. Homer Wheeler, an agricultural chemist at the University of Rhode Island, was briefly the president of the university. He went to work for the American Agricultural Chemical Co. The company's fortunes rose and fell, but he was always considered an expert on fertilizers. He and his wife, Frieda, lived at 386 North Fullerton Avenue.

Dr. Leo Sternbach worked for the medical research department at Hoffman-LaRoche in Nutley. He and his staff developed Valium and Librium, two widely prescribed antianxiety drugs that were very successful for the company. They also developed one of the most effective ways to synthesize biotin, a useful component of the vitamin B complex. He was declared "inventor of the year" by the New York Patent and Copyright Law Association in 1987.

Dr. A.K. Ganguly studied in India. He obtained his PhD in England under the guidance of Nobel laureate Sir Derek Barton. Ganguly came to the United States and joined Schering Plough as a senior research scientist. He retired 30 years later as senior vice president of the research division. He and his team had made great strides in antibiotics, anticancer drugs, and cholesterol-lowering agents.

Dr. Charles P. Covino invented a way to impregnate aluminum with Teflon. He started the Magnaplate Company to manufacture cookware under the brand name Tufram. He and his wife, Sylvia, lived at 31 Woodmont Road and then at 10 Heller Way.

A couple of Montclairians were early pioneers in the radio industry. Paul Godley went to the University of Illinois shortly after the nation's first radio station was set up in Chicago in 1908 and found his calling. He developed the Paragon receiver for shortwave radios. He went to Scotland to receive the first transatlantic shortwave transmission in 1921. He came back to Montclair and went to work for Adams Morgan on Alvin Place. Adams Morgan, which made radio kits, was founded by Montclairian Alfred P. Morgan. He held several radio patents, and designed gun-fire controls for use during World War I. The company was dissolved in 1927. Morgan started writing books and articles explaining radio to adolescents. The books were popular, and Alfred became a bestselling science author.

Montclair has been blessed with hundreds, perhaps thousands, of excellent doctors. Only a few can be mentioned here. Perhaps most interesting were the African American doctors, who were not allowed to practice in the Montclair hospitals. Dr. Arthur Thornhill came to Montclair in 1908 from Barbados. He attended high school in Montclair, graduated from Howard University, then Howard Medical School. He returned to set up a private practice in 1927. He was on staff at the Kenny Memorial Hospital in Newark. He was also physician to the Essex County Board of Child Welfare and served on the executive committee of the Essex County Tuberculosis League. After World War II, he was invited to join the courtesy staff of Mountainside Hospital. He retired as one of the most respected doctors in Montclair history. He died in 2001 at the age of 105. Dr. Walter Darben also practiced at Kenny Memorial. He and his wife, Mamie Jean, lived at 266 Orange Road. Their daughters, Norma Jean and Carole, got wrapped up in researching family history and wrote a fascinating cookbook and slice of African Americana called *Spoonbread and Strawberry Wine*. By 1914, Dr. Frank Thompson Sr. opened up a practice. He was the first African American doctor in town. He and his wife, Julia, had their home and office at 18 Elmwood Avenue.

Lillian Gilbreth
(married to Frank Gilbreth Jr.)

Gilbreth was born in 1878 to William and Annie Moller of Oakland, California. As loving as he was, her father would not let her attend college. She was a capable negotiator, though. She changed his mind by agreeing to go to the University of California, close to home. She majored in English literature. She was the first female commencement speaker at the university. She earned a master's degree in English literature at Berkeley and immediately began doctoral programs in literature and psychology.

She met Frank Gilbreth en route to Europe in 1903. Her chaperone was Gilbreth's cousin. Frank had been a building contractor in Boston, and he had a theory about improving efficiency by studying how people performed their jobs. His study involved breaking jobs into essential components, analyzing them, and organizing the components to get the job done in the best way. This practice later became known as "time and motion study." Lillian changed schools, changed her doctoral program to the science of management, and jumped headlong into her husband's field. He published her dissertation, *The Psychology of Management*. They married in 1904.

They believed that New York would be the best place to establish their new consulting firm, and moved to 68 Eagle Rock Way (the house is gone, but the carriage house remains). Lillian and Frank tested their methods on their children, and the house became

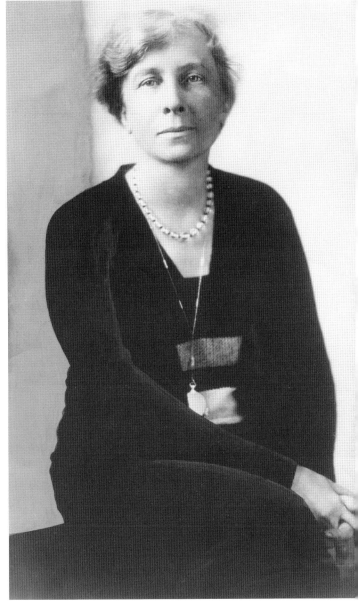

known as the home of the "Gilbreth System." They were blessed with many subjects to study, having six boys and six girls. A book and movie, both called *Cheaper by the Dozen*, described the boisterous life in the household. Even though Lillian was swamped with work and childrearing, her son Frank said that she managed to make each child feel as if he or she was an only child. Her mother-in-law lived with them, and they were able to afford servants.

Lillian carried on the business after her husband died, although she encountered resistance from some male clients. Her accomplishments were mind-boggling. She was a professor at several colleges. She wrote, or coauthored, dozens of books. She was the first woman to be elected to the National Academy of Engineering. She was awarded the Hoover Medal, which is jointly bestowed by five engineering societies. And she received a total of 28 honorary degrees.

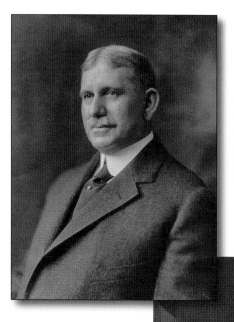

Isaac Newton Lewis
Lewis, a colonel in the US Army, was an expert in military ordnance. He invented devices for weapon systems and developed the Lewis machine gun, which was used extensively by the Allies during World War I. Although he refused royalties beyond $1 million for his gun, his other inventions made him wealthy. He gave liberally to charity. He and his wife, Mary, lived at 1 Russell Terrace.

Edward Weston
Weston, an electrical engineer, was credited with over 300 patents. He started in the electro-plating industry. Realizing that a more stable source of power was required, he developed a generator, called a dynamo, that provided consistent energy. He started a company to produce dynamos in Newark, and this led to him improving other electrical devices. He and his wife, Edith, lived at 37 North Mountain Avenue. (Photograph by George French.)

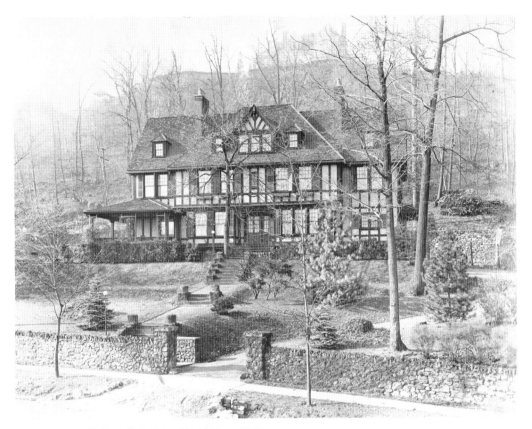

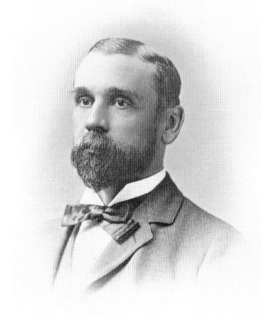

Rudolph Hering

Rudolph and Hermine Hering probably built this house on Lloyd Road. Hering consulted on water and wastewater problems. His greatest achievement was the Chicago Sanitary and Ship Canal, which diverted sewage from Lake Michigan (Chicago's source of drinking water) to the Mississippi River watershed. The American Society of Civil Engineers offers an annual award in Hering's name to the person with the best ideas for protecting waterways.

Edgar Burgess

Burgess's father was one of the first to build floating grain elevators. Before mechanical elevators, stevedores manually unloaded grain from ships, and ports became choke points in the flow of grain from farm to market. He became president of his father's company and then headed the International Grain Elevator Co. He and his wife, Elizabeth, lived in a mansion that was once at the top of Union Street.

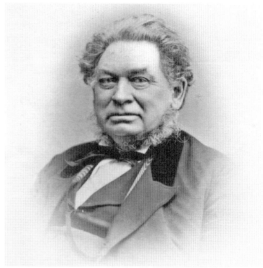

Stephen Parkhurst
Parkhurst invented a machine to card wool, which was the process of separating the fibers. Realizing the need to clean the clumps of fiber before carding, he formed a company to make burring machines to clean wool and cotton gins. He and wife, Thankful, came to Montclair in 1857. Their son-in-law, Warren Holt, founded one of the schools that attracted families to the area.

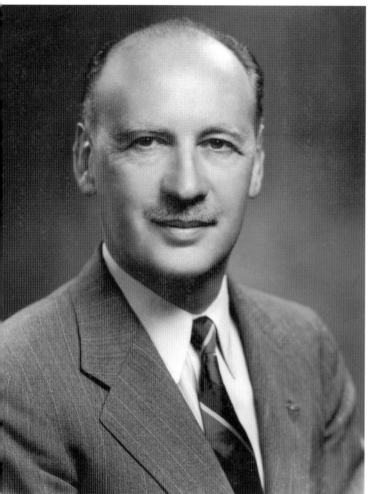

Harry Bruno
Bruno, born in England, grew up at 15 Gates Avenue, but moved away from Montclair after his parents died. He built gliders while at Montclair High, and became an aviation pioneer. He flew for the British during World War I. Bruno ended his friendship with Charles Lindbergh when Lindbergh campaigned against aid to England. Although Bruno remained involved with aviation, he made his money in public relations. (Photograph by Delar.)

Edwin "Buzz" Aldrin Jr.

Aldrin, an American astronaut, was the second man to walk on the moon. He grew up in Montclair. His father, Edwin Sr., was an aeronautical engineer. The younger Aldrin got the nickname "Buzz" because an older sister had trouble with the pronunciation of the word "brother." The name stuck, and he later made it his legal first name.

He graduated from West Point (no Air Force academy yet existed) with a degree in mechanical engineering. He flew 66 missions during the Korean War, shooting down two enemy fighters. *Life* magazine published a photograph, taken from Aldrin's gun camera, of an enemy pilot ejecting from a plane. Buzz became an aerial gunnery instructor and was then made an aide to the dean of faculty at the brand-new Air Force Academy. He was promoted to flight commander of the 22nd Fighter Squadron, based in Bitburg, Germany. He continued his studies at MIT, and was chosen to be an astronaut in 1963. He developed techniques to perform extra-vehicular activities (EVA), which earned him a place on Gemini 12 with Jim Lovell. His spacewalk on that mission proved that work outside the capsule was possible.

Aldrin made history on July 20, 1969, when he followed Neil Armstrong onto the lunar surface. Aldrin was supposed to have been the first on the moon, but Armstrong's position in the lunar module made that impractical. After the moon mission, Aldrin was made the commandant of the Air Force Test Pilot School. He resigned from active service after 21 years, and Montclair honored him with a parade in September 1969.

He returned to the Air Force as a managerial consultant. His career since has been a whirlwind of personal appearances, consulting, writing, and movie and television roles. He lived at 25 Princeton Place. (Photograph by NASA.)

John Love

Dr. John J. Hervey Love studied at the University of New York and came to Montclair in 1855. He was the only doctor in an area that included Bloomfield, Great Notch, Verona, Cedar Grove, and Montclair (known then as West Bloomfield).

When the Civil War started, Love joined the 1st Regiment, Essex County Militia. Disappointed because the regiment saw no action, he took a position with the 13th Regiment of New Jersey Volunteers. He was no desk jockey, though, serving in the field during the battles of Williamsburg, Antietam, Chancellorsville, and Gettysburg. In 1862, he was made surgeon-in-chief of the 3rd Brigade, 12th Army Corps. Later that year, he was promoted to surgeon-in-chief of the entire 1st Division. He became a lieutenant colonel when the 12th Army Corps was merged with the 11th Army Corps and went west with General Sherman. Love took part in the battles of Lookout Mountain, Missionary Ridge, and Chattanooga. He resigned his commission in 1864 and returned to Montclair.

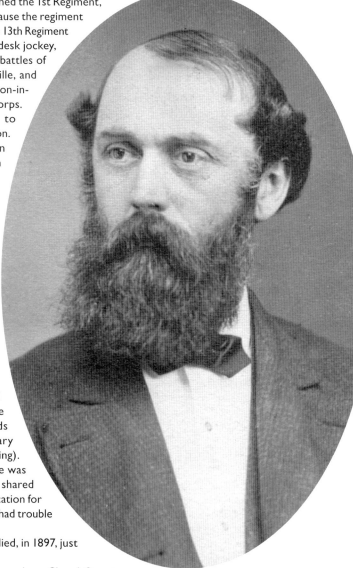

Love resumed his practice, but also found time to be involved with every aspect of town improvement. He served on the town committee, was president of the Montclair Water & Gas Company, and was president of the school board. He became the chief surgeon of Mountainside Hospital in 1891.

Love's motto was, "We can afford to pay for anything that will elevate the town." He advocated for paved roads and was a founder of the public library (on the second floor of his office building). As president of the school board, Love was often at odds with fellow citizens, who shared his desire to provide a high-quality education for Montclair students but who sometimes had trouble with how much that education cost.

He remained active until the day he died, in 1897, just a few hours after assisting in surgery.

He and his wife, Frances, built a house on a large Church Street lot. They sold that house to the Montclair Club, probably the largest social organization in Montclair. The club used it briefly until it erected a new building. That building no longer exists. It stood about where the municipal parking lot on The Crescent is now. The front lawn extended to about where The Stockpot now stands. The South Fullerton house was knocked down to make room for the Montclair Public Library.

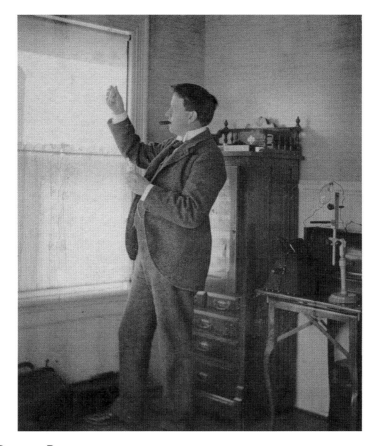

Dr. James Spencer Brown

Dr. Brown was born in Waterbury, Connecticut, and his mother brought the family to Brooklyn after his father died. He worked in business for a couple of years, but decided to study medicine. Brown graduated from the College of Physicians and Surgeons at Columbia University. He interned at New York Hospital, then did postgraduate work at the University of Heidelberg and Guys Hospital in London. He began his medical career with a better education than most of his contemporaries. His mother had relocated and was living in Montclair, and Brown moved there in 1885. He was the youngest physician in town when he arrived.

Dr. Brown was one of the founders of Mountainside Hospital in 1891. He served as an attending surgeon until 1900, when he became chief of surgery. He held that position until 1928, when he retired, at which time he was the oldest practicing physician in town.

What made Brown unique among Montclair doctors was his willingness to keep up with the latest procedures and to take on rarely performed surgeries. He traveled all over the world to attend lectures and presentations on the newest techniques. He introduced the use of X-rays as a diagnostic tool to fellow staff members at Mountainside and was one of the first to maintain a laboratory for diagnosing disease. Many of the things he did seem commonplace now, but they were quite original then. In the 1880s, he was among the first surgeons in the country to perform an appendectomy. He became a consultant to several large hospitals in the region. Although he was older, he served as the chief surgeon of the 82nd Division during World War I, and was conferred the rank of major.

Brown, Montclair's town physician for many years, guided the town through the typhoid scare in the late 1890s. He was the first person in Montclair to own a car. His first wife was Helen Russell, daughter of Thomas Russell. After she passed away, Brown and his second wife, Leonore, lived and had an office on South Fullerton, in a building that is no longer there.

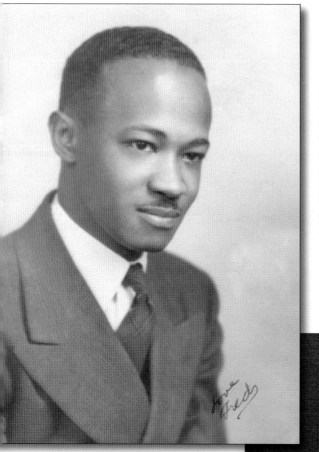

Frederick W. Douglas

Montclair was segregated in the early 20th century, and African American doctors were not allowed to practice in the town's three hospitals. Their patients had to be seen by white doctors when they were admitted. Dr. Frederick Douglas, a graduate of Howard University, was the first African American doctor to earn attending status at Mountainside Hospital.

John Kenny

Kenny, personal physician to George Washington Carver and Booker T. Washington, founded a clinic at Tuskegee, Alabama. When the Ku Klux Klan burned a cross on his property, he rushed his wife, Frieda, and his family north. Unable to practice in Montclair hospitals, Kenny started his own in Newark. The Kenney Memorial Hospital became Community Hospital. Kenny's sons, John and Howard, also became doctors. (Courtesy of the Tuskegee University Archives, Tuskegee University.)

Dr. Levi Halsey
In 1903, Halsey became staff anesthesiologist at Mountainside Hospital, serving there for 46 years. He was staff president in 1923 and served on the board of health. He and his wife, Florence, lived at 61 Church Street. The house was moved across Trinity Street to make way for the church that stands there now. The house is now one of the buildings on the southwest corner.

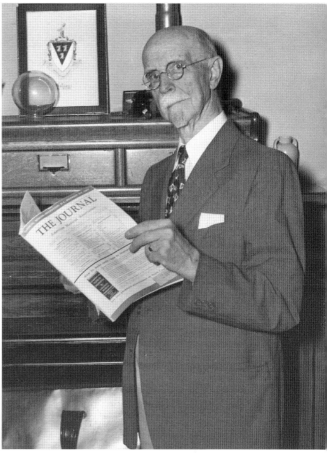

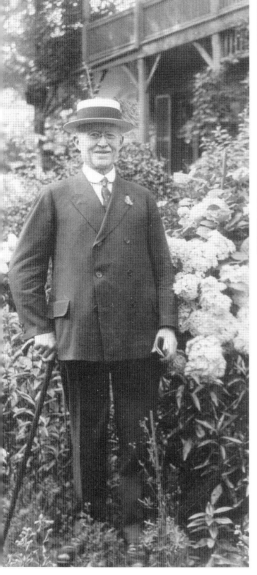

Samuel Watkins
Watkins, a dentist, arrived in Montclair in 1876. Being involved in many dental societies, he did not have much time for civic affairs. However, he was a creator of Montclair's volunteer Hook and Ladder Company No. 1. Watkins was also a historian. He married Philip Doremus's daughter, Mary. Doremus, Watkins, and his brother-in-law, Edwin Goodell, all wrote histories of Montclair.

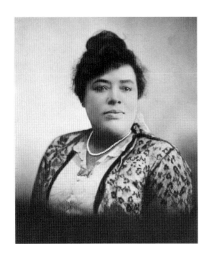

Eva Clay
Clay taught public health. She was an Army nurse at Camp Grant, in Rockford, Illinois, and a nurse at the municipal court in Newark. She moved to 119 Lincoln Street after her husband died. Her great-grand uncle, James Willis, lived with her in later life. He was one of the oldest remaining Civil War veterans when he died in 1942. (Photograph by L.A. Bamberger & Co.)

John R. Fitzgerald
Fitzgerald, along with Edgar Ballou, was one of Montclair's first African American dentists. He and his wife, Jennie, lived at 25 Washington Street, and his first office was at 154 Bloomfield Avenue. They moved home and office to 89 Elm Street. He was active in town politics and ran unsuccessfully for a spot on the town commission in 1960.

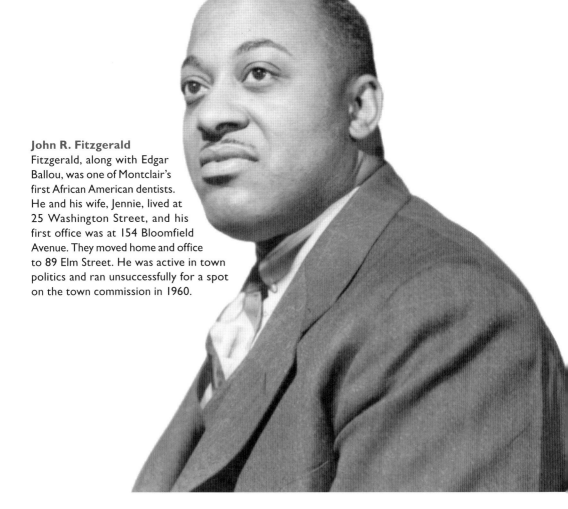

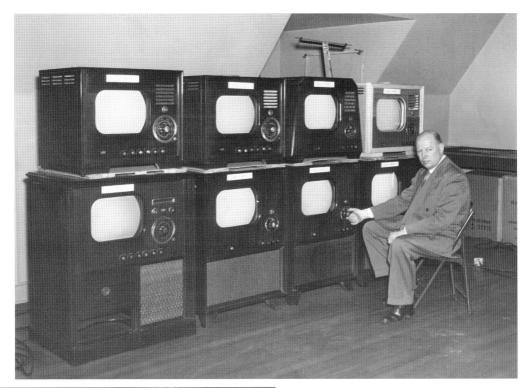

Allen Dumont

Dumont's improvements to the cathode ray tube made it relatively inexpensive and durable. In 1931, he started his own company with $1,000. At first, the firm made oscilloscopes. In 1940, it started making televisions for the home market. Dumont and his wife, Ethel, lived in Cedar Grove. The laboratory, which also served as the first factory and store, was on Valley Road in Montclair.

John Barclay

Barclay studied to be a dentist, but continued to work part-time as a telegraph operator. He remained with Western Union and was promoted to vice president. He invented a device to transmit telegraphs using alphabetic letters, eliminating the need for Morse code. He was elected to the town commission. Shown in this photograph are commissioners Louis Dodd (seated) and, from left to right, Charles Philips, John Barclay, John Picken, and E. Mortimer Harrison.

Carleton Ellis

When he was 21 and a student at MIT, Ellis invented a paint remover. His father, however, thinking that Ellis did not have enough experience to succeed, refused to loan him money for development and sales of the thinner. Ellis borrowed $500 from other sources and set up a business, then obtained a patent and hired students to help. A few months later, the Pennsylvania Railroad ordered a rail car full of the thinner. Paint companies noticed and started copying his invention. Without much more than bravado to go on, he sued one of the companies. Much to everyone's surprise, the court ordered the company to pay royalties. Ellis brought suit against all of the other guilty companies. He proudly brought the first royalty check to his father. It was for $1,000.

Ellis married Birdella Wood in 1901. They moved to 143 Gates Avenue in 1908. He set up a laboratory at 98 Greenwood Avenue and a branch lab in Key West. He mentored a large number of engineering and chemistry

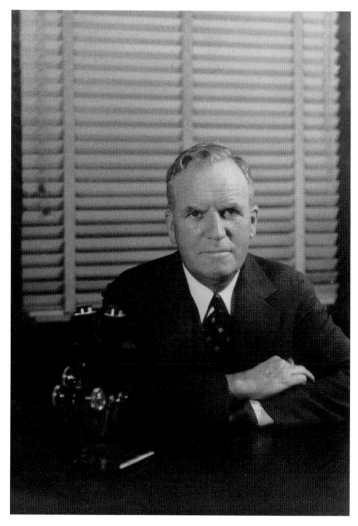

students, and they developed over 100,000 chemical compounds through the years. They patented at least two compounds, or inventions, every month for 25 years. In the end, Ellis and his workers came up with over 800 patents. Thomas Edison's labs developed 2,332 patents worldwide (1,093 in the United States). John O'Connor came in second, with 949 patents in the medical field, and Ellis was third.

Ellis developed the "tank and tube" process of cracking petroleum, which boosted the octane rating of gasoline and allowed cars to run better and without knocking. The end product was called anti-knock gas. Ellis considered it his most important invention. He became a part-time consultant to Standard Oil.

His labs produced a wide variety of inventions, from synthetic oils, which replaced natural oils that became difficult to obtain from the Pacific when Japan and China went to war, to fireproofing, used to protect airplanes from incendiary bullets. He invented isopropyl alcohol, which is used as a disinfectant and made shampoo inexpensive. His products improved paints, plastics, soaps, and cosmetics. As if that were not enough, his firm also developed a dog biscuit that became very popular. (Courtesy of the Special Collections Research Center, Syracuse University Library.)

CHAPTER SEVEN

Religion

Montclair churches have been a major influence in the town's history. Over the years, 69 churches have been established. Many clergy have been leaders of the community. Unfortunately, only nine clergy can be featured in this chapter.

Montclair was originally part of Newark, which was settled by Congregationalists from Connecticut. Later, the church in Newark joined the Presbyterians. Many of the original settlers of Cranetown (Montclair) were Presbyterians and worshiped in nearby Newark or Bloomfield. In 1837, the Presbyterians organized the West Bloomfield Presbyterian Church and worshiped at an old schoolhouse. In 1856, First Presbyterian Church was erected on what is now the site of the Hinck Building. Later, seven other Presbyterian churches were founded, including Trinity Presbyterian, Central Presbyterian, Grace Presbyterian, Italian Presbyterian, Presbyterian Church of Upper Montclair, South Presbyterian, and the African American Trinity United Presbyterian.

Speertown (Upper Montclair) was originally settled by the Dutch, who practiced the Dutch Reformed faith. The settlers worshiped at Brookdale Reformed Church in nearby Bloomfield. It was not until 1897 that they established the Montclair Heights Reformed Church on Valley Road.

The honor of the first church building in Montclair goes to the Methodist Episcopal Church, which erected a small building at 194 Bloomfield Avenue in 1836. In 1879, the Methodists moved to North Fullerton Avenue. Organized in 1880, the first African American church in Montclair, St. Mark's Methodist Episcopal Church (now St. Mark's United Methodist Church), rented and later purchased the building at 194 Bloomfield Avenue. After a devastating fire on Good Friday, April 1, 1947, severely damaged Montclair's oldest church building, the congregation built its current church on Elm Street. The church's ministers and members have been instrumental in founding the African American YMCA, YWCA, and Home Corps. One of the town's featured ministers is the Rev. Frederick Handy, who was the first president of the Montclair branch of the NAACP.

The next group to start a church was the Episcopalians. In 1846, they built a small chapel on Pine and Cherry Streets. In 1865, they built St. Luke's Episcopal Church on Hillside Avenue and St. Luke's Place. Later, in 1890, the congregation moved to the current building on South Fullerton Avenue. In 1881, Cliffside Chapel was established in Upper Montclair by the Presbyterians and Congregationalists. In 1888, the Episcopalians purchased Cliffside, establishing St. James Episcopal Church, which now has the honor of being the oldest church building in town. St. John's Episcopal Church was established in 1896. Another featured clergyman is the Rev. Luke White, who was the minister of St. Luke's Episcopal. He assisted in establishing Trinity Episcopal Church, which was formed in 1916 by 44 African American and West Indian members of St. Luke's, which had segregated seating for African Americans. The Rev. George Marshall Plaskett, who was a civil rights activist, was the first minister.

The Roman Catholic Irish immigrants were the next group to establish a church, in this case the Church of the Immaculate Conception on Washington Avenue, in 1857. Father Mendl led the church in building an elementary school and its current structure on North Fullerton Avenue in 1892. Later, Father Farrell

was instrumental in building the high school, rectory, and convent. Two other Catholic churches were established, St. Cassians (Irish) and Our Lady of Mount Carmel (Italian). African American Catholics experienced discrimination at the Catholic churches in Montclair. The St. Peter Claver congregation began worshiping in the basement of the Church of the Immaculate Conception in 1931, and, later that year, moved to a house at 51 Elm Street. Raising money from the community, the current church on Elmwood Avenue was dedicated on November 5, 1939.

The Congregationalists (now United Church of Christ) established the First Congregational Church on South Fullerton Avenue in 1870. The most prominent local minister in the 19th century was the Rev. Amory Bradford. Not only did he preside over a prominent congregation, he was instrumental in encouraging members of his church and others to establish various social and cultural groups in Montclair, including the Children's Home, Montclair Club (a focal point of the Montclair social scene for many years), and the Outlook Club. Three other congregational churches were formed: Christian Union Congregational, Swedish Church (now Evangelical Covenant), and Watchung Congregational.

The Baptists, which organized in 1886, built the First Baptist Church (later the Masonic Temple) on South Fullerton Avenue in 1891. The most famous minister to serve Montclair was Harry Emerson Fosdick, who went on to become the founding minister of Riverside Church in New York. Under his leadership, the Baptists erected their second building on Church Street (now Christ Church).

In 1887, Union Baptist became the second African American church to be established in Montclair. Incorporated on September 20, 1889, the congregation took 10 years to complete its first church building on Portland Place. The church has had several prominent ministers, including John Love, who served for 47 years; William Gray, who was a congressman and leader of the black caucus; Matthew Carter, who was the first black mayor in Montclair; and Deual Rice, a civil rights activist.

A group led by the Reverend Tucker of Newark formed the third African American church, St. Paul Baptist, in 1902. A church building was built at 15–17 Hartley Street in 1906–1908. The congregation worshiped at this location until the current church building at 119 Elm Street was completed in October 1963. Some of its prominent leaders included the Reverends Deuel Rice, Ansel Bell, and James Billips.

Four additional African American Baptist churches were formed: Bright Hope Baptist, New Calvary Baptist, Rising Mt. Zion Baptist, and Emanuel Hope Baptist.

The Unitarians organized in 1897 and built a church on Church Street in 1904. A prominent preacher featured here is the Rev. Edgar Wiers, who led members in founding several social and cultural organizations in Montclair, including Unity Institute, Unity Concerts, and the Montclair Equal Suffrage League.

Other Christian churches included the First Lutheran (1895), First Church of the Christian Scientists (1901), the Salvation Army (1906), Montclair Quakers (1926), Unity, Calvary Chapel of Montclair (1989), and Montclair Community Church (1991).

Other African American churches included First Church of God in Christ, Trinity Temple Church of God in Christ, The First Seventh-Day Adventist, New Jerusalem Holiness, Apostolic Holiness, and Mount Carmel Holy. In the second half of the 20th century, 12 more African American churches were established, including the Church of Christ, founded by Howard Johnson, who also founded a church in Newark. In the last 10 years, seven more churches have come to Montclair.

Shomrei Emunah Temple was established in 1905 in Glen Ridge at 959 Bloomfield Avenue. In 1951, the congregation dedicated a new temple at 69 Park Street. Rabbi Schnitzer was instrumental in building a new school at the new location.

Bnai Kesnet, a reconstructionist temple, renovated the old Florence Lang Residence on South Fullerton Avenue in the late 1990s.

In the 1930s and 1940s, a Moorish Science Temple was located in Montclair. Muslims have worshiped at Temple Masjid Ul Wadud on Bloomfield Avenue since 1994.

People of the Baha'i faith have worshiped in Montclair since the early 1900s.

Although mainline church attendance has declined in recent years, there are still 47 churches in Montclair today.

Amory Howe Bradford

A descendent of William Bradford, governor of the Plymouth Colony, Amory Howe Bradford was born in Granby, New York, in 1846. His father, Benjamin Bradford, a minister and abolitionist, later served a church in Cedar Grove. After graduating from Andover Theological Seminary in 1870, Amory Bradford was called by a newly formed First Congregational Church in Montclair. The church met at the Pillsbury Building until the original First Congregational Church building was erected in 1870 on South Fullerton Avenue. Bradford became an influential member of the community, spending his entire career at the church even though he was called to other churches, including the Westminster Chapel in London, where he served for two months in 1893. He also occasionally substituted for the esteemed Henry Ward Beecher at his Plymouth Congregational Church in Brooklyn. Bradford served a top position in the denomination as moderator of the National Council of Congregational Churches. He was highly regarded by his clergy peers in Montclair and elsewhere.

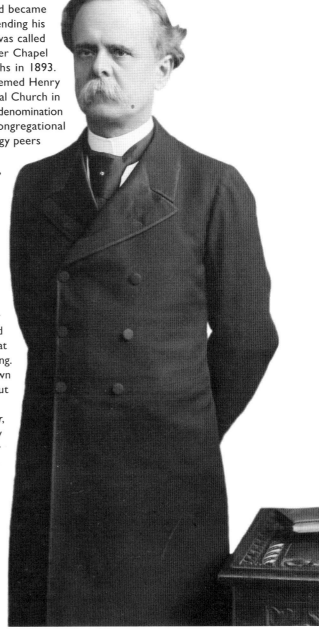

Not only did he establish the new church, which had many prominent Montclair families, but Bradford was known for his encouragement of the development of several social welfare or community clubs. Some of these organizations included the Montclair Club, the major social club in town; Outlook Club; Children's Home; Mountainside Hospital; Bach Festival; and the Village Improvement Association.

One day in 1911, his daughter Stella helped him walk the short distance to his daughter Cornelia's home on Orange Road. He collapsed in front of the house and died shortly after, at the age of 64. The whole town grieved his passing. Businesses closed for the day, flags were flown at half staff, and massive numbers turned out for his funeral.

In *Amory Bradford: First Citizen of Montclair,* Royal Shepard Jr. writes that fellow pastor Harry Emerson Fosdick said of Bradford, "I lived for twelve years in a community to which in the early years a young minister had come, and where for forty years he stood as the central influence in the town's life. . . . The height of his mind, the usefulness of his spirit, the liberality of his thought, made all the people gladly acclaim him as the foremost citizen." (Photograph by H.J. Whitlock; courtesy of Montclair Historical Society.)

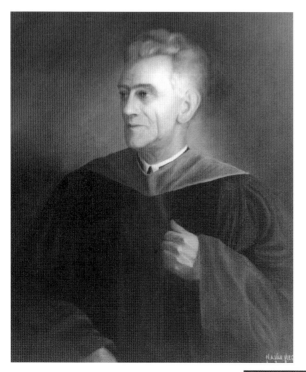

Archibald Black
Born in Scotland, Archibald Black was the minister of First Congregational Church from 1921 to 1945. He was interested in youth ministry and built the church's education building. His brother, Hugh Black, a renowned minister, taught at Union Theological Seminary and lived in Montclair. A third brother, James, was a minister in Scotland. (Painting by Howard Van Vleck.)

Right Rev. Msgr. Edward Farrell
Father Farrell came to serve the Church of the Immaculate Conception in 1924. Under his leadership, the church established Immaculate Conception High School in 1929 and remodeled the grammar school. He also built a new convent and rectory and reorganized the Catholic cemetery. A talented organist, Father Farrell composed several songs. (Photograph by Master Portrait Studio.)

Frederick Handy

Frederick Handy arrived in 1915 to serve the St. Mark's Methodist Episcopal Church, founded in 1880. A year after coming to Montclair, he was instrumental in establishing the Montclair chapter of the NAACP, serving as its first president. He left the church in 1923. (Courtesy of St. Mark's United Methodist Church.)

John C. Love

Ordained at the age of 19, the Rev. John C. Love began his 47-year ministry at Union Baptist Church in May 1899. During his long tenure, the original church building was completed and, later, two wings were added. The current building, shown here, was erected in 1926. Love, a believer in practical gospel, promoted home ownership and economic independence. (Courtesy of the Montclair Historical Society.)

Harry Emerson Fosdick

Montclair's best-known minister was Harry Emerson Fosdick, the most prominent liberal preacher of his day. Raised in Lancaster, New York, Fosdick decided he wanted to be a missionary at the age of seven. He graduated from Union Theological Seminary in 1903, and a year later, the young minister began his career at First Baptist Church of Montclair, then on South Fullerton Avenue. Under his leadership, the church membership grew, and he developed the Emanuel Bible School in Upper Montclair and a missionary society. When Fosdick began his ministry, he felt self-conscious in the pulpit, until one day he felt the spirit, and discovered his gift of preaching. Due to the increase in membership drawn to Fosdick's charismatic leadership, the congregation built a larger church on Church Street (now Christ Church). Fosdick's brother, Raymond, who also lived in Montclair, was involved with the Rockefeller Foundation.

In 1915, Fosdick was offered a faculty position to teach practical theology at Union Theological Seminary in New York. He was a popular speaker at churches and universities. In addition, he had a radio program called *National Vespers* for 19 years. After World War I, he was invited to be a regular guest preacher at the First Presbyterian Church on Fifth Avenue. While there, he preached his controversial liberal sermon, "Shall the Fundamentalists Win?" in which he spoke in opposition to fundamentalist theology. According to James Gordon in "One Heaven of a Fellow" in the December 1947 *Cornet*, in his sermon, Fosdick said, "The idea that any creed can be final is as incredible to me as that the interpretation of the physical cosmos could stop at Newton or Einstein. . . . But while ideas of God may change and ought to, that does not mean anything has happened to God." This sermon was widely distributed and caused a great stir. The Presbyterian General Assembly decided to ask Fosdick to resign, using a church rule that guest preachers cannot stay permanently. In 1924, he resigned from the church. On his last day there, people lined the streets to get inside to hear his final sermon.

Shortly after, Fosdick was approached by John D. Rockefeller to be the minister of the Park Avenue Baptist Church. Fosdick declined. Rockefeller did not give up, and built the famed Riverside Church for Fosdick. He retired from there in 1946. (Photograph by Phillipe; courtesy of Montclair Historical Society.)

Edgar Wiers

Edgar Wiers, community leader and social activist, was called to be the minister of Unity (Unitarian) Church in 1906. Under his leadership, the church (below) sponsored several cultural groups, including Unity Forum; Collegiate Pulpit; Unity Institute, which featured travel lectures, drama clubs, and choirs; and Unity Concerts. In addition, he established a community nursery school. He supported the suffrage, civil rights, and peace movements, and was a strong believer in Prohibition, saying, "I'm a strict prohibitionist, I don't play golf or bridge and I'm a thorough pacifist." (*Montclair Times*, March 28, 1931.) Wiers also was founder and president of the New Jersey Association for the Blind and served on the state Blind Commission. He died at the age of 58 after an operation. (Below, photograph by H.A. Strohmeyer; courtesy of Unitarian Congregation.)

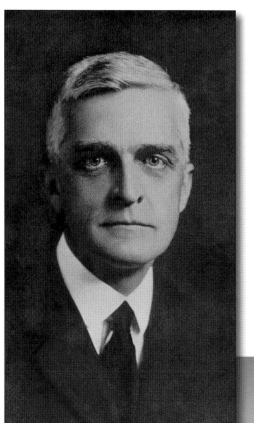

Luke White

Luke White served as the minister of St Luke's Episcopal Church from 1916 to 1945. While at St. Luke's, he erected the church's school and remodeled the interior of the church. A strong advocate for racial justice, White helped the black members of his congregation to establish Trinity Episcopal Church on Willow Street and secured the Rev. George Marshall Plaskett as their first minister in 1916.

Jeshaia Schnitzer

Rabbi Schnitzer served the Congregation Shomrei Emunah from 1951 to 1979. During his tenure, the new temple at 67 Park Street was dedicated, and the Jewish School was opened. In addition, he practiced marriage and family therapy. He felt deeply about racial equality in Montclair. For example, in 1962, when a black student of his was turned away from the town pool, he left the pool with all of his students. (Photograph by Salov.)

CHAPTER EIGHT

Social Reformers

Many renowned Montclair citizens have been active in various social causes. This chapter focuses on activists who were involved in women's rights, civil rights, and social welfare reform.

The women's rights movement began in the 19th century with the struggle for the right to vote. The most famous women's rights activists in Montclair were the Blackwell family: Lucy Stone, founder of the American Women's Suffrage Association; Elizabeth Blackwell, the first woman doctor in the United States; and her sister Emily, the third woman doctor. During the Civil War, Lucy Stone and her husband, Henry Blackwell, moved to Montclair, where she owned property on North Mountain Avenue. At the same time, the Blackwell sisters established a convalescent home near Lucy's property. Emily lived in Montclair in the early 1900s.

At the turn of the 20th century, Montclair women became more organized in their fight for the right to vote. As early as 1903, there was a small group of women at the Unitarian Church called the Political Club interested in suffrage. In 1910, the Montclair Equal Suffrage League was established by Florence Foster and other members of the Unitarian Church. The league marched in parades, went door to door, and gave speeches at the corner of Midland and Bloomfield Avenues. Montclair residents Beatrice Kinkead and Phebe Scott, members of the National Women's Suffrage Association, were arrested at demonstrations in front of the White House in July and November 1917, respectively. Kinkead was held in jail for three days until she was pardoned by President Wilson. In 1920, at an anniversary dinner celebrating passage of the 19th Amendment the prior year, one of the first chapters of the New Jersey League of Women Voters was formed.

A thriving African American community developed as southern African Americans migrated to Montclair starting after the Civil War and through the Great Migration in the early 20th century. Although many black residents worked for wealthy Montclair residents in domestic jobs, there were African American businessmen and professionals who set up firms and practices in Montclair or nearby Newark. African Americans built their own churches and established several organizations.

Although for the most part blacks lived in harmony with whites in Montclair, there was an underlining current of Jim Crow de facto segregation in the first half of the 20th century. African Americans were barred or not welcomed at many businesses, organizations, and churches in town. This discrimination led to the development of some of the African American organizations. For example, the two most important social organizations, the "colored" YMCA and the YWCA, were formed, because blacks were not allowed at the Montclair YMCA. African Americans were also barred from positions in the town's schools, fire and police departments, and from practicing medicine at the three hospitals. Another form of discrimination was housing. African Americans were discouraged and not shown homes in certain neighborhoods in Montclair, especially Upper Montclair and other wealthier sections in town. Most black residents bought homes in the third, fourth, and fifth wards.

African Americans fought against these discriminatory practices. The Montclair branch of the NAACP was established in 1916 by a group led by the Rev. Frederick Handy of St. Mark's Methodist Episcopal

Church. In the early 20th century, the Montclair NAACP branch worked to end segregation of movie theaters, businesses, and public schools and to promote the hiring of African American policemen and other town employees. In 1930s and 1940s, leaders of the NAACP included Mary Hayes Allen and Octavia Catlett.

In 1947, the American Veterans Committee and the Montclair Forum, with assistance from the NAACP, conducted a civil rights audit. The survey studied racial discrimination in the areas of employment, housing, public health, education, and public facilities. The audit found that there were many areas of discrimination in town, and opened the Montclair community to these issues. Two years after the audit was conducted, the Montclair Civil Rights Commission was formed. It remained active until the 1970s. In the 1990s, the commission was reactivated.

In the 1950s and 1960s, activists continued to make gains in the fight for equal rights. In the 1950s, gains were made in the hiring of teachers and in integration of the hospitals. Efforts were made to hire more African Americans to town positions. The first black fireman, John Sterling, was appointed to the department in 1952. Later, he was promoted to the rank of assistant fire chief. The first African American superintendent was Charles Baskerville Sr., who was appointed superintendent of streets and sewers in 1957. In 1964, in another civil rights audit, African Americans were still found to be struggling in the areas of fair housing, equal employment, and access to health care. The 1960s would see the long struggle to desegregate the public schools. In 1968, Montclair would elect its first black mayor, Matthew Carter.

Montclair citizens have been very generous with their time and compassion for people in need. Social welfare reformers have worked on behalf of children, the poor, immigrants, and minorities. Too many helping organizations have been formed in Montclair to list here. To name a few, there are the Town Improvement Association, Montclair Grassroots, American Red Cross, Montclair Volunteer Ambulance, Service and Fraternal Clubs, Montclair Neighborhood Development Corporation, Home Corps, Salvation Army, Montclair Community Chest, the Council of Social Agencies, and the United Way.

Children are often the most vulnerable, so it is not surprising that there have been several organizations geared toward the care of children. The first social welfare organization in Montclair was the Children's Home, founded by Elizabeth Habberton in 1881. The home, which offered refuge for poor children from New York and Montclair, was first located on Plymouth Street and later moved to Gates Avenue.

There were several nurseries founded in Montclair. One of the earliest was the Montclair Day Nursery. Another day care program was the Frog Hollow Day Care Center, founded by Mrs. L.M. Connor. In 1960, Mrs. Connor reached out to children in the Frog Hollow neighborhood through her Kennedy Human Relations Project for Youth. In 1970, she purchased a building at 174C Valley Road, where she opened a community center offering programs for youth, providing counseling, and operating a daycare facility. In 1978, the Frog Hollow Day Care Center moved to 17 Talbot Street, where it offered a daycare program for low-income children.

In the early 20th century, programs designed to assist immigrants were in demand. The first settlement house in New Jersey was the Whittier House in Jersey City, organized by Cornelia Bradford, who retired to Montclair after giving over 30 years of service to immigrants.

Montclair had two neighborhood centers that offered a variety of educational and cultural programs for Italians and African Americans: Junior League Community House (1926) and Minnie Lucey Community House (1929).

Two other Montclair residents who worked with the poor were Ballington and Maud Booth, who founded the Volunteers of America.

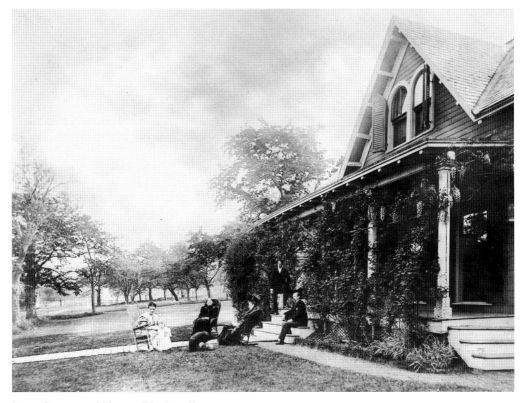

Lucy Stone and Henry Blackwell

Montclair's most prominent social activist family was the Blackwells. The first Blackwells to move to Montclair were Henry Blackwell and his wife, Lucy Stone. Born in 1818 in Coy's Hill, Massachusetts, Stone graduated from Oberlin College in 1847. She was already a well-known women's rights activist and abolitionist when she met Blackwell at one of her lectures in Cincinnati, Ohio. Born in England in 1825, Blackwell, who was a realtor, was actively involved in the antislavery and women's suffrage movements. The couple had one daughter, Alice, who later continued her parents' fight for women's rights. The young couple moved to Orange, New Jersey, where Stone purchased property in her name. There, she made her well-known stand of refusing to pay her property taxes, claiming, "My reason for doing so is that women suffer taxation and yet have no representation." The town officials auctioned off some of the family's belongings to pay her tax bill. The items were bought by a neighbor and returned to her. During the Civil War, Stone and Blackwell moved to Montclair, and Lucy purchased their property, now at 118 North Mountain Avenue (shown here). They lived there a few years before moving to Newark; however, Lucy continued to own the property for many years.

Together, Stone and Blackwell worked toward the cause of women's suffrage. Initially, Stone worked with Elizabeth Cady Stanton and Susan B. Anthony. In the 1860s, Stone was involved in the founding of the American Equal Rights Association. In 1867, she spoke about women's rights before the New Jersey legislature and became involved in the establishment of the New Jersey Women's Suffrage Association in Vineland, New Jersey. In 1869, Stone had a falling out with Stanton and Anthony over the 15th Amendment, which gave black men but not women the right to vote. Stone supported the amendment, while Stanton and Anthony did not. Stone and Blackwell then organized the American Women's Suffrage Association as a rival to Stanton and Anthony's National Women's Suffrage Association. Stone's organization was interested in fighting the cause on a state level. In 1890, the two groups came together under the name National American Woman Suffrage Association. Stone died in 1893, and her husband died in 1909.

Elizabeth and Emily Blackwell
English medical pioneers Elizabeth and Emily Blackwell immigrated to New York in 1832. In 1849, Elizabeth (left), the first female doctor in the United States, received a medical degree from Geneva College. Emily (below) graduated from Western Reserve University in 1854. The sisters established the New York Infirmary for Women and Children in lower Manhattan and, later, the Women's Medical College. During the Civil War, they established a convalescent home in Montclair. The facility, on 20 acres of land, had a large veranda, allowing patients to sleep outdoors. Elizabeth returned to England in 1869 and became that nation's first registered female doctor. Emily, who remained in the United States to operate the infirmary and medical school, retired in 1900 and lived with two other doctors on Plymouth Street. Both sisters died in 1910.

Jane Barus

A native of Kansas City, Jane Barus came to Montclair in 1928. She was active in the New Jersey League of Women Voters, holding several local and state offices, including president (1943–1947). She served as the chair of the Mayor Committee on Housing and the Montclair Housing Authority. In 1947, she was one of eight female delegates of the New Jersey Constitutional Convention.

John Mott

Mott resided in Montclair from 1900 to 1926. For over 30 years, he was the national secretary for the intercollegiate YMCA and chairman of the executive committee of the Student Volunteer Movement, a predecessor of the Peace Corps. In 1895, he organized the World Student Christian Federation, a predecessor of the World Council of Churches. During World War I, he received a Distinguished Service Medal for his work with war prisoners. Mott won the 1946 Nobel Peace Prize.

Elvira Fradkin

Born in 1891 in New York, Elvira Kush Fradkin devoted her life to the peace movement and women's rights. After earning a BA from Vassar in 1913 and an MA from Columbia University, she moved to Montclair in 1916, where she became involved in promoting international relations at various women's clubs. That year, she married Leon Fradkin, a dentist. In 1922, she formed the international relations committee of the Montclair Women's Club. Out of this committee came the Cosmopolitan Club, which strove to promote understanding between people from different countries and cultures. Fradkin also became involved with the League of Women Voters, serving as the state chair of the New Jersey Joint Council on International Relations.

Fradkin became interested in the threat of chemical attacks by air and wrote a pamphlet about chemical warfare published by the Carnegie Endowment for International Peace in 1929 and a book, *Air Menace and the Answer*, in 1934.

Fradkin was a promoter of the League of Nations and, later, the United Nations. She attended several League of Nations and UN conferences on world peace and disarmament. In 1932, she was one of three unofficial delegates to represent the United States at the World Conference for the Limitations and Reductions of Armaments in Geneva, Switzerland. Later, she served on the education committee for the League of Nations. In 1950, she wrote another book, *World Airlift: The United Nations Air Police Patrol*, in which she promoted the use of air police patrol to prevent wars and strengthen the United Nations. In 1951, she organized the United Nations Institute at Montclair State University.

She was also the cofounder of Women Action Committee for Everlasting Peace (1945–1952), cofounder of the New Jersey Committee on the Causes and Cures of War (1928–1940), and president of the New Jersey branch of the American Association for United Nations. Fradkin died in 1972. (Photograph by Mary Christine Studio.)

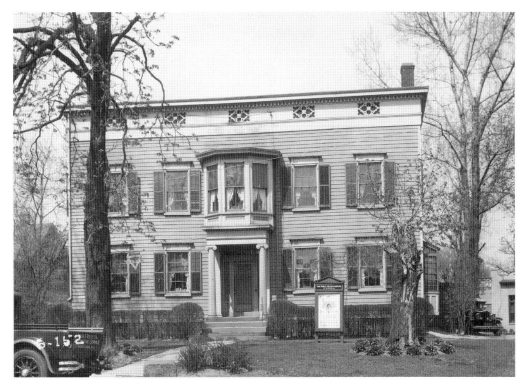

Hortenese Tate, YWCA

In 1912, the African American YWCA was established in Montclair. The association moved into the Crane House (shown here) in 1920. The following year, Hortenese Tate was hired as the YWCA's cultural director and head of the Girl Reserves program. She later became an English teacher in Newark. Well-loved within the African American community, she died at the age of 104 in 2003. (Photograph by R. Lacey Merritt.)

Charles Bullock, YMCA

In 1905, a group of African Americans, barred from attending Montclair's main YMCA building, founded a black branch. In 1916, Charles Bullock became the director. He had already organized or founded black YMCAs in Charlottesville, Brooklyn, and Louisville. During his tenure in Montclair, the black YMCA building shown here was opened on Washington Street in 1927. (Photograph by George French.)

Mary Hayes Allen

Born in 1875, Mary Hayes Allen's parents were Confederate general J.R. Jones and Malinda Rice. In the 1870s, Malinda Rice worked as a servant for General Jones, who acknowledged his illegitimate daughter and supported her education. However, Allen, other than displaying a picture of her father on the mantel, never talked about him to her children. She was raised by her uncle John Rice and his wife, Dolly. In the 1890s, she attended Hartshorn College in Richmond, where she met her first husband, Gregory Hayes, a visiting speaker. He was the prominent president of Virginia Seminary, an African American college in Lynchburg. Mary and Gregory Hayes were married in 1895 and eventually had seven children; five survived to adulthood.

Through her life with Gregory Hayes, Mary nurtured her passion for the cause of civil rights, befriending many leaders of the day, including W.E.B. Dubois and Booker T. Washington. In 1906, Gregory Hayes died of Bright's disease. Mary Hayes was appointed the interim president of the seminary for two years and continued to teach there. In 1911, she married William Allen, a lawyer, and had three more children. Her early civil rights contributions in Virginia included helping to organize a chapter of the NAACP in Lynchburg and assisting people who were losing their homes due to unpaid taxes. In 1920, William and Mary Allen joined the Great Migration of southern African Americans, settling in Montclair. The family moved to a house on Valley Road near Bloomfield Avenue, where they were initially met with hostility from white neighbors. William Allen set up a law practice in Newark, and Mary became active in the YWCA and in the local and state chapters of the NAACP. She led various protests against theaters, stores, and other organizations that discriminated against African Americans. At the Claridge Theater in the 1920s, she refused to sit in the section for blacks, launching a protest. However, it was not until the 1930s that the Claridge stopped its discriminatory practice. Mary became the secretary of the local NAACP branch shortly after moving to Montclair. In 1930, she became the president of the chapter, serving in that capacity until her death in 1935. Carrie Allen McCray chronicled her mother's life in her book *Freedom's Child*.

Matthew Carter

In 1964, Matthew Carter was the first African American to be elected to Montclair's town council. Four years later, he became Montclair's first black mayor. Some of his accomplishments in Montclair included gains in affordable housing and improving education and economic development for minorities. He was also was the chair of the New Jersey Civil Rights Commission and sat on the board of the Urban League.

Minnie Lucey, Dance Class

In 1915, Minnie Lucey (far left) was hired by the Baldwin Street School as a social worker to assist in Americanizing the school's Italian children. In 1929, she established the Baldwin Street Community House, which offered educational and social programs for Italians and African Americans living in the neighborhood. Well-loved within the Italian community, she died in 1930 at the age of 45.

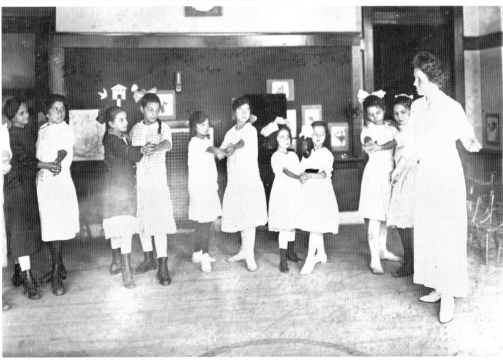

Cornelia Bradford

Cornelia Bradford, sister of Amory Bradford, founded Whittier House in 1893. The facility, which was the first settlement house in the state, was located in Jersey City, which had a large immigrant population. For 32 years, Bradford lived and worked among the immigrants. In addition, she worked tirelessly to pass state labor and social legislation. When she retired in 1926, she moved in with her niece, Stella, in Montclair. (Courtesy of Jersey City Free Public Library.)

Stella Bradford

Bradford, trained in physical medicine, worked with children affected by rheumatic fever, polio, and arthritis. In 1903, she opened a practice in Montclair. Bradford was a member of the TB committee and established a fresh-air school. She was the director of Mountainside Hospital's physical medicine department. Shown here are, from left to right, Julia Bradford and her children Arthur, Nelly (standing), Stella (seated), and Clara. (Photograph by Samson, Courtesy of Montclair Historical Society.)

Elizabeth Habberton

In 1881, inspired by a sermon by Amory Bradford on helping poor children, Elizabeth Habberton and nine other women of the First Congregational Church opened a children's home, the first charitable organization in Montclair. The first year saw 125 children from New York visit the home, on Plymouth Street. Local poor children stayed at the home, which later moved to Gates Avenue. In 1944, it merged with the Family Welfare Society.

Lillie Margaret Connor

In 1931 at the age of 14, Lillie Connor came to live with relatives in Montclair. In 1960, she saw some children picking flowers from the neighbors' yards to give to their parents. She mentored the children through her Kennedy Human Relations Project for Youth. In 1970, the Frog Hollow Day Care Center was formed. The Boy Scout troop seen here was started in 1972.

Ballington and Maud Booth

Natives of England, Ballington and Maud Booth founded Volunteers of America. The couple lived in Montclair from 1896 to 1916. Ballington Booth, son of Salvation Army founder William Booth, became a commander in the organization, serving in Europe and Australia. In 1887, the Booths were sent to command the Salvation Army in the United States. Ballington resigned from the organization several years later over differences with his father regarding administration policies. After the split, the Booths founded Volunteers of America, which provided social welfare and relief programs. Maud became especially interested in prison reform, organizing halfway houses and advocating for a parole system. When Ballington died in 1940, Maud led the organization until her death in 1948. (Courtesy of Library of Congress, Photographs and Prints Division, LC-USZ62-103997 and LC-USZ62-121593.)

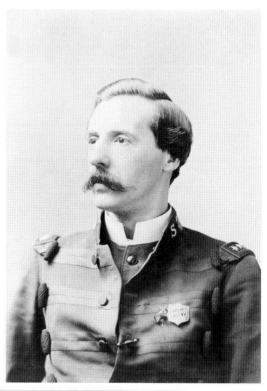

CHAPTER NINE

Education

Throughout the town's history, Montclair educators have striven to provide excellent education for the children. This chapter will feature only a few of the many educators who have made a difference in young people's lives in Montclair and beyond.

In 1740, the first school was built near the corner of Orange Road and Church Street. In 1812, it was moved further down Church Street. A school was built by the Methodists in 1825, on Glenridge Avenue, called Washington School. Dutch settlers built Speertown School in 1827 on the corner of Bellevue Avenue and Valley Road in Upper Montclair. From 1860 to 1887, Central School (now the administrative buildings) was built on Valley Road and Church Street. The Central School complex included both primary and high schools. The schools were originally part of Bloomfield. In 1850, the three schools operated as separate school districts.

In 1874, Randall Spaulding was hired to head the Central School District. He was later instrumental in combining the three entities into one school district. A progressive educator, Spaulding strove to improve education in Montclair by recruiting outstanding teachers and reforming the basic curriculum to include other topics, such as nature studies and manual instruction. Two years after Spaulding's arrival, the schools were highlighted in a display at the Philadelphia Centennial Exposition.

As the population grew, more schools were built, among them Mount Hebron (1884–1910), Cedar Street (1888–1907, renamed Nishuane), Chestnut Street (1890), Second High School (1893, renamed Spaulding, next to Hillside), Maple Avenue (1896, renamed Glenfield), Montclair Heights (1895), Watchung (1900), Hillside (1909), Grove Street (1914), Baldwin Street (1914, renamed George Washington), Current High School (1915), Rand (1925), Edgemont (1927), George Inness Junior High (1927), Bradford (1927), Northeast (1936), Southwest (1949), and Charles H. Bullock (2010).

Although Montclair had a reputation for good schools, there was an undercurrent of racial imbalance, due to the discriminatory practices and the neighborhood school system. Montclair did not employ African American teachers until 1946, when Mabel Frasier Hudson was hired to teach at Glenfield. However, few other African Americans were hired to teach at Glenfield and Nishuane, which had the highest number of African American students. The first black instructor at the high school was Jeanne Heningburg, a physical education teacher, in 1957.

African Americans initially resided throughout Montclair. Over time, though, discriminatory housing practices—the refusal of realtors, landlords, and homeowners to sell or rent homes to African Americans in predominately white neighborhoods such as Upper Montclair—created African American neighborhoods in the Fourth and parts of the Third and Fifth Wards. Glenfield and Nishuane had the highest number of African American students, and smaller numbers attended Rand, Chestnut, and Hillside. To further add to the imbalance, white parents could send their children to a different elementary school if they lived near a neighborhood school with a higher number of black children. This issue came to a head in June 1961, when parents from Glenfield and other concerned citizens organized to protest that the Glenfield students were not receiving the same supplies and quality of education as the students in the

Upper Montclair schools. The quest for equal education for all Montclair students lasted over a decade. In November 1967, New Jersey's state education commissioner ruled in the case Rice v. Montclair Board of Education. The Montclair Board of Education was mandated to create a more racially balanced school system. After unsuccessfully trying several plans to remedy the situation, the board in 1976 and 1977 developed the magnet school system, which has served as a national model for other communities.

Montclair citizens dissatisfied with the public school system developed several private schools. In the early 19th century, Montclair had two boarding schools for boys: Mount Prospect Institute (1838–late 1850s), founded by Warren Holt; and Ashland Hall (1845–c. 1871), founded by the Rev. David Frame. Hillside Seminary for Young Ladies (1855–1872) was founded by the Rev. Ebenezer Cheever and, four years later, was taken over by the Rev. Aaron Wolfe.

Montclair Kimberly Academy was formed from three private schools. In 1887, Montclair Academy was established when a group of parents hired John MacVicar to organize a new school for their sons. The first year, MacVicar purchased property on Clinton Avenue, and soon the school had grown from 18 to 32 male students. The following year, property on Walden Place was purchased and a building was erected. The curriculum included college preparatory classes, but also emphasized science and physical education. From 1891 to 1909, the school, which included military instruction, was known as the Montclair Military Academy. The Montclair Academy was sold to Walter Head in 1912, and he sold it to the Montclair Academy Foundation in 1948.

A group of parents recruited Mary Waring to head up another private school in 1906. Waring, who had earlier taught at a high school, established the Mary Waring School and Studio (later Kimberly School) on Plymouth Street. She brought in a friend, Mary Jordon, to be her co-principal, and the two women ran the school until 1941. In 1950, the school had outgrown its location on Plymouth Street and purchased the old Montclair Athletic Club property on Valley Road. Both boys and girls attended the primary grades, but only girls were taught in the higher grades.

Brookside was founded as a coed school in 1925 in an old house on Orange Road. The school offered progressive courses for nursery school through sixth grade. Brookside was purchased by the Montclair Academy Foundation in 1950. In 1974, Montclair Academy and Kimberly School combined to create Montclair Kimberly Academy.

There are three Catholic schools in town. The earliest is Immaculate Conception, founded by Father Mendl in 1881 at its original location on Washington Street. In 1889, the school, which included primary through high school instruction, was opened at the new church site on North Fullerton Avenue. In the 2000s, the Immaculate Conception high school became a private school no longer affiliated with the church, and the primary school closed. St. Cassian Church founded a school for primary grades in 1953 on Norwood Avenue in Upper Montclair. In 1920, Mother Aveline of the Dominican Sisters of Caldwell purchased the home of Morgan Ayres and founded Lacordaire School. Both boys and girls attended the lower grades, but the upper grades were reserved for girls. Mount Carmel Guild operated a special education school from 1961 to 1980. Two other schools are Montclair Cooperative (1963) and Deron, a special education school.

For 76 years, the Adult School of Montclair has offered a variety of continuing education programs. Montclair Normal School, established in 1904, offered a two-year program for teachers. In 1930, it became the Montclair State Teachers College and offered a four-year degree. In 1966, the word "Teachers" was dropped from the title, and the school earned university status in 1994. Today, it is one of the largest state universities in New Jersey. The college operated the College High School from 1929 until 1969 as a way to train its education students.

Katherine Gibbs, a renowned secretarial and business school, took over the Kimberly School building on Plymouth Street in 1950. Around 2006, the school moved to Livingston, where it closed in 2010.

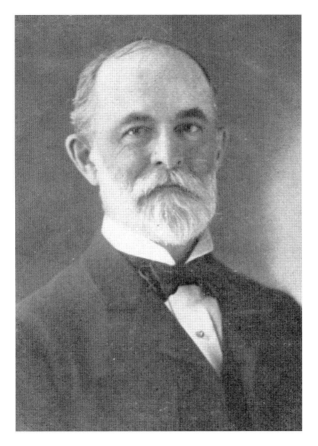

Randall Spaulding

Born in 1845 in Townsend, Massachusetts, Randall Spaulding was a progressive educator who organized the Montclair school system, serving for 38 years as the head of the high school and superintendent of the schools. He studied at the Lawrence Academy in Groton, Massachusetts, and went on to Yale University, where he graduated in 1870. Upon graduation, he organized a high school in Rockville, Connecticut, where he stayed for three years before traveling and studying in Germany. In 1874, he was offered a position in Montclair, originally in charge of school district No. 8 (Central School). In 1894, when the three school districts merged into one, he was given a dual appointment as superintendent of all the schools and head of the high school. Spaulding is credited with building the Montclair schools into an excellent school district by recruiting the best teachers, promoting higher educational standards, and erecting five new school buildings. He was known for his progressive educational ideas, including the introduction of a manual training program and nature and language studies, which were not common subjects at the time. In addition, he added a year to the high school course. Initially, his improvements were not popular with some homeowners, who did not want to pay higher taxes. Over time, however, Spaulding became well loved by teachers, students, and parents. In 1912, he retired. His farewell dinner was attended by past students and teachers.

Education was not his only interest. A love of nature led Spaulding to travel to Arizona and Colorado in 1883 and 1886, respectively, where he collected plant specimens for his personal studies and for the Smithsonian. Photography was another interest, and some of his images have been preserved at the local library.

Spaulding died in 1916 after a long illness. In 1893, a high school was built next to Hillside School. When the current high school was built in 1915, the old high school building was renovated as a primary school and renamed Spaulding School in his honor.

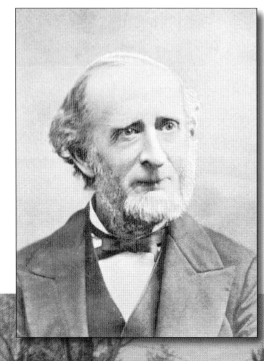

Aaron Wolfe, Hillside Seminary for Young Ladies

Born in 1821 in Mendham, New Jersey, Aaron Wolfe was a pastor and educator. After studying at Union Theological Seminary, he pursued his ministry in Florida. In 1855, he returned to the Northeast by train, shipping his papers, sermons, and books on a sailing vessel. After his belongings were lost at sea, Wolfe decided that this was a sign from God to give up his ministry for teaching. He found a position at Springer Institute for Young Ladies in New York. In 1859, Wolfe took over the Hillside Seminary for Young Ladies from its founder, Reverend Cheever. Hillside, a popular boarding school for girls, closed in 1872. The student's boardinghouse (below) is now the Montclair Inn for senior citizens.

Mary Kimberly Waring, Kimberly School
Mary Kimberly Waring, a progressive educator, founded Kimberly School in 1906. In 1893, she taught English and Latin at the high school in Montclair and later taught at Mary Wheeler School in Providence, Rhode Island. In 1906, a group of prominent Montclair businessmen approached her in consideration of starting a new progressive school that would include college preparatory and art and music courses. Waring returned to Montclair and purchased 33 Plymouth Street, where she established the Mary Waring School and Studio, which included primary to high school grades. She brought with her Mary Jordan, a friend from Smith College, to serve as the co-principal. Waring had a warm personality and was much loved by her teachers and students. She retired in 1941. (Painting by Edith Cleaves Berry.)

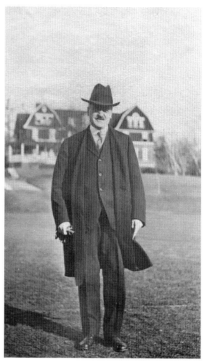

John MacVicar, Montclair Academy

In 1887, John MacVicar became the first headmaster of Montclair Academy. MacVicar's father was the educator Malcolm MacVicar, chancellor of McMaster University in Canada. The younger MacVicar worked as a superintendent in Union City, Michigan, while pursuing his education at Toronto University and the University of Rochester. In 1887, a group of prominent businessmen wanted a college preparatory school for their sons. MacVicar, only 27 years old, arrived and convinced them that he was the man for the job. Originally, he purchased property on Clinton Avenue for a small school. Later, property was purchased on Waldon Place. In 1891, the school was renamed the Montclair Military Academy. Below, MacVicar, along with his wife, Harriet Ames, and their daughter are in the back row at far right. (Right, courtesy of Montclair Kimberly Academy.)

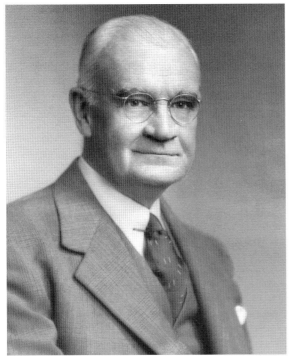

Walter Head, Montclair Academy
In 1925, John MacVicar sold the academy to Walter Head, who served through the difficult Depression and war years. Head became involved with the International Rotary Club, serving as its president from 1939 to 1940. In 1948, he transferred ownership of the academy to the Montclair Academy Foundation. In 1951, Head became the president of Bergen Junior College, which became Fairleigh Dickenson's Teaneck campus. (Photograph by Master Portrait Studio.)

Jean Henderson
Montclair native Jean Henderson was one of the town's first African American principals and was the first in Moorestown, New Jersey. She received her MA in curriculum and teaching from Columbia University, and was especially interested in reading curriculum. Henderson was the granddaughter of Charles Bullock, director of the black YMCA.

Ernest de Alton Partridge, Montclair State University

Partridge served as the third president of Montclair State Teachers College, from 1951 to 1964. He joined the faculty of Montclair State in 1937, teaching psychology and sociology. In addition, he was the dean of instruction and served as the first director of the New Jersey School of Conservation. Partridge was an expert in adolescent psychology and audiovisual education. He developed the visual education program for the Boy Scouts in 1937 and helped launch *Continental Classroom* on NBC, the first network course offering college credit. During his tenure as president, several buildings were erected on campus, including the first two dormitories, Russ and Chapin Halls. Partridge also broadened the scope of the school from a teachers college to one encompassing other studies. The word "Teachers" was dropped from the name of the college in 1958.

CHAPTER TEN

Sports

Montclair has always cheered on its local athletes, including school and intramural teams and amateur and professional players. Clary Anderson and Butch Fortunato coached a Montclair High football dynasty, Anderson for 25 years with Fortunato as his assistant. Fortunato then took the helm for another 15 years after Anderson left. Together, they compiled a spectacular number of wins. Fortunato also taught history and was the school's athletic director. He also served the town as director of parks and public property and as director of public safety. Many great players came of age under their guidance, such as Jim McGurk, who was captain of the undefeated 1943 team, and Ron Burton, who was the quarterback on the undefeated 1964 team. Burton went on to be one of Colgate University's greatest quarterbacks.

Of course, Montclair has had great teams and athletes in other sports. Montclair High lacrosse had an outstanding record of 144 wins and 10 losses during the 13 years that Gill "Goober" Gibbs coached, until his untimely death in 1978. The string of wins was carried on by Houston Weber, who had been a star player at Montclair State, and by Dean Witty. The town's other high schools, Montclair Kimberly, Lacordaire, and Immaculate Conception, have fielded championship teams in their leagues. Montclair State has had glorious years in girls' basketball. Montclair's Carole Blazejowski was named NCAA female basketball player of the year in 1978. She scored a phenomenal 3,199 points in her career at Montclair State and still holds the NCAA record for points per game. She followed up her college career with fabulous years in amateur and professional basketball. She was prevented from competing in the Olympics, however, when the United States boycotted the 1980 Moscow games.

One of Montclair's most famous amateurs was golfer Jerome Travers, who won four amateur opens (1907, 1908, 1912, and 1913). He competed for championships in England and France in 1914, and had the distinction of winning the 1915 US Open as an amateur. He retired from competition and taught golf professionally. In 1957, Montclarion Tom Peoples won the New Jersey Golden Gloves boxing championship. His professional career did not pan out, however. Harrison P. Smith, an 800-meter runner at Harvard, lost in a close race between Yale-Harvard and Oxford-Cambridge in England, but set the world record in the 1900 Olympic trials. He came to Montclair and started a little dynasty of his own. His son, Morgan, captured the state mile championship in 1925. Another son, Danny Smith, broke Morgan's record. Danny and two other sons, Tommy and Phillips, kept outdoing each other in the mile at Rutgers.

The town has also had its share of professionals. George Earnshaw, who grew up at 182 Bellevue, played in the minor leagues before Connie Mack signed him to the Philadelphia Athletics. A pitcher with a murderous fastball, Earnshaw and fellow Montclairian "Mule" Hass brought the Athletics victory in the 1929 and 1930 World Series. Earnshaw won 127 games in nine years, playing for the Athletics, the White Sox, the Brooklyn Dodgers, and the St. Louis Cardinals.

Billy "Brud" Johnson grew up in Montclair, attending Immaculate Conception School. A third baseman for the New York Yankees, Johnson came in fourth in the voting for the American League Most Valuable Player award in 1943, his rookie year. He played on four championship Yankee teams in five seasons, and finished his career with the St. Louis Cardinals.

Patricio Scantlebury was a pitcher and first baseman. He was born in the Canal Zone and came to the United States to play for the Negro National League, where he spent most of his career. In 1965, he was called up to play for the Cincinnati Reds. He did not think he was being used effectively and threatened to quit rather than be a "mop up" pitcher. He was sent to the Toronto Maple Leafs, a triple-A team. He played and coached for the semi-pro Clifton Phillies, which brought him to Montclair. He and his wife, Celeste, lived at 47 Woodland.

Yogi Berra's sons, Tim and Dale, were Montclair High School football standouts. Tim went on to play for the Baltimore Colts, and Dale was signed by the Pittsburgh Pirates baseball team and was part of the team that won the 1979 World Series against Baltimore. He played two seasons for the Yankees, and his father was the manager for part of that time.

Wally Choice, a Montclair High basketball star, was the first African American captain of Indiana University's famous Hoosiers. He played briefly for the Harlem Globetrotters, then came back to Montclair and started a pharmacy on Bloomfield Avenue. He was extremely active in community affairs, founding Montclair Grass Roots. The field house at Glenfield Park was renamed to honor his involvement. Bill Bradley, a basketball star at Princeton, was on the 1964 gold medal Olympic team and was NCAA player of the year in 1965. A Rhodes scholar, Bradley played professionally for the New York Knicks for 10 years, winning two championships. He also became famous for his work after basketball. He was a three-term US senator from New Jersey and a presidential candidate. Bill and his former wife, Ernestine, lived in the Rockcliffe Apartments.

Among the town's football heroes is Jeff Mills, who was born in Montclair. Mills played linebacker for the New York Giants, the Denver Broncos, and the San Diego Chargers. Jay Johnson was a linebacker for the Philadelphia Eagles. The list also includes New York Giants great, and now talk-show host, Michael Strahan, who briefly ran for mayor when he lived in Montclair. And who can forget the unbelievable catch that Montclair football star David Tyree made to keep the New York Giants alive in Super Bowl XLII? The Giants went on to win the game. Tyree also played for the Baltimore Ravens.

One of the most important sports figures who lived in Montclair was John McMullen. He played with quarterback Butch Fortunato, and graduated in 1936 as class valedictorian. McMullen went to the Naval Academy and stayed in the Navy until the end of the Korean War. He started a naval architectural firm and moved back to Montclair. He was a limited partner in the New York Yankees organization, but found that too confining, so he bought the Colorado Rockies, a hockey team. He brought them to New Jersey, renaming them the New Jersey Devils. He also owned the Houston Astros baseball team.

Althea Gibson

Althea Gibson was a tennis superstar. She was born in South Carolina, but grew up in Harlem. Gibson met Rosemary Darben, another aspiring tennis player, early in her career. She lived with Darben at 69 Pleasant Way and married Darben's brother, William.

Gibson came across Dr. William Johnson, who became her mentor. Through her association with him, she had access to a higher level of play, eventually joining the United States Tennis Association. She won 56 titles as an amateur, and then turned professional. Among her championships are Wimbledon (1956), three straight doubles titles at the French Open (1956, 1957, 1958), and US Open singles (1957, 1958). The Associated Press named her Female Athlete of the Year in 1957 and 1958. She was the first African American female so honored.

Segregation plagued her early career. She was not able to turn professional until she was in her thirties. When she reached 40, she could no longer compete with the younger players, and retired from the sport. She taught tennis on both the amateur and professional level, and tried her hand at professional golf, without much success. Gibson played in exhibition tennis matches before Harlem Globetrotters basketball games, and this reportedly earned her $100,000 in one year. She was named the New Jersey commissioner of athletics, a position she held for 10 years. She wrote an autobiography, *I Always Wanted to Be Somebody*. Gibson died in 2003 in East Orange. (Photograph by Fred Palumbo, courtesy of the Library of Congress, Prints and Photographs Division, Reference Number LC-USZ62-114745.)

Lawrence "Yogi" Berra

Yogi Berra was born in St. Louis. He got the nickname "Yogi" when a childhood buddy thought he resembled an Indian snake charmer in a movie they were watching. Before he was associated with the Dodgers, Branch Rickey asked Berra to join the Cardinals, but Berra thought the offer too low. The same year, Berra signed with the Yankees and became one of the game's greatest catchers. He played in the Yankees farm system until World War II, when he was drafted. Berra served in North Africa and Italy, and was at Omaha Beach on D-Day. He resumed play in the Yankees farm system after the war.

The manager of the Giants saw Berra play and offered the Yankees $50,000 for his contract. The Yankees manager had never seen Berra play, but figured he must be good if the Giants wanted him so badly. Berra was brought up to the majors in 1946. A 15-time All-Star, Berra was named MVP of the American League three times (1951, 1954, and 1955).

In 1964, Berra became the manager of the Yankees. They won the American League pennant that year, but lost the World Series in seven games. The Yankees let him go, and he became a player-coach for the Mets. He was named the Mets manager in 1972 and brought the team from last place to the National League championship in 1973. They lost the World Series to the Oakland Athletics.

In 1976, he returned to the Yankees as a coach. In 1984, he once again became the manager. The team finished third that year, and Berra was abruptly dropped during the course of the 1985 season. He became a coach for the Houston Astros and remained with them until 1992. At that point, he retired.

He and his wife, Carmen, have lived in Montclair for many years. They have been active in town affairs and have given generously of both time and money to local charities. (Courtesy of the National Baseball Hall of Fame Library, Cooperstown, NY.)

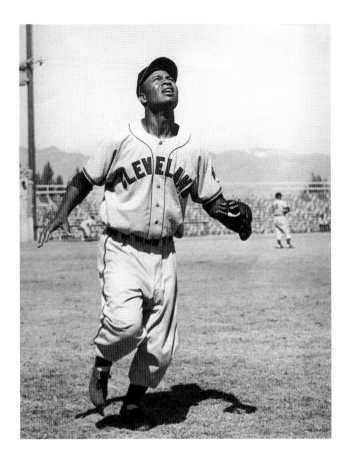

Larry Doby

Doby was born in South Carolina. His father played semi-pro baseball. After his parents divorced, his mother moved to Paterson, New Jersey. After the death of his father, Larry came north to be with his mother. He played baseball, football, and basketball at Eastside High in Paterson. The football team won the state championship during this time, and was invited to a game in Florida, but were told that Doby, the only African American on the team, would not be allowed to play. The team voted not to participate in the game.

He attended Long Island University while playing professional baseball for the Newark Eagles of the Negro National League. Doby served in the Navy during World War II, and returned to the Eagles after the war.

The Cleveland Indians had considered drafting a player from the Negro Leagues before Branch Rickey and the Dodgers did so, but the league's commissioner rejected their proposal. The Indians' owner thought Doby a better candidate than Jackie Robinson. In fact, some of the Dodger higher-ups thought so, too. Robinson was chosen to be the first African American to play in the Major Leagues, and Doby was the second, six weeks later. He faced the same indignities that Robinson faced, but did not get the same kind of recognition in the press. People just aren't as interested in the second man to do something as they are in the first. Doby did become the first African American to hit a home run in a World Series game. He faced insults, however, and was ignored by teammates. When the Indians played in the South, Doby had to find separate lodging, often staying with local families. Nonetheless, he had a stellar career as a center fielder with a solid batting average. He played 13 years with the Indians, the White Sox, and the Detroit Tigers. He held various jobs in and out of baseball until 1978, when he was hired to manage the White Sox. Once again, Jackie Robinson had beaten him to the position, having managed the White Sox in 1974. Doby finished his career in the New York Nets front office. He died in 2003. He and his wife, Helen, lived at 45 Nishuane. (Courtesy of the National Baseball Hall of Fame Library, Cooperstown, NY.)

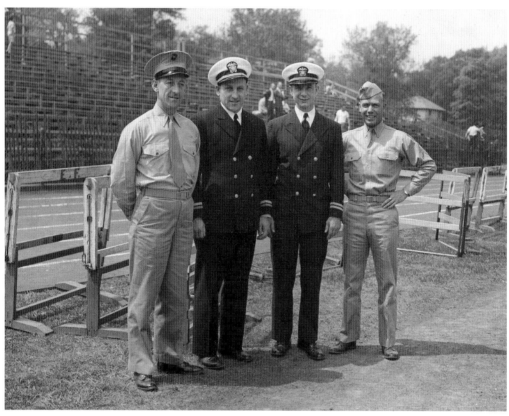

Clary Anderson

Anderson (far left) was a fullback and quarterback for Montclair High School. The *Star-Ledger* named him one of the top 10 players of the 1920s. He quarterbacked for Colgate. After coaching briefly at Blair Academy, Anderson began an illustrious 25-year career as the MHS football coach, amassing over 200 wins and overseeing several undefeated seasons. Butch Fortunato was his assistant during this era. Anderson later coached at Montclair State College.

Angelo "Butch" Fortunato

Fortunato was spectacular at track. But when he signed up for baseball, which overlapped with the track season, his coach, Clarence Woodman, also the athletic director, threatened to dissolve baseball in order to keep Fortunato on the track team. While playing football, Fortunato was on the team that Bloomfield defeated 53-0. He swore vengeance and, as MHS football coach, saw his team defeat Bloomfield 58-0 in 1946. Fortunato coached MHS football for four decades.

George "Mule" Haas
Haas played baseball for Montclair High, and became a star for the Philadelphia Athletics. His home runs won the 1929 World Series for them. He played for the Athletics until 1939, after which he coached and managed in the minor leagues. A sportswriter may have given him his nickname by suggesting that his home run "kick" won a game. He and his wife, Marie, lived at 109 Valley Road.

Leonard Coleman
Coleman, a football star at Montclair, was essential to its 8-0-1 season in 1966. The *Star-Ledger* named the team number one in the state. After earning master's degrees in public administration and education, he served as a missionary in Africa. Gov. Thomas Kean appointed him to be commissioner of energy, and he also served as commissioner of community affairs. Coleman worked for Major League Baseball and was elected president of the National League in 1994.

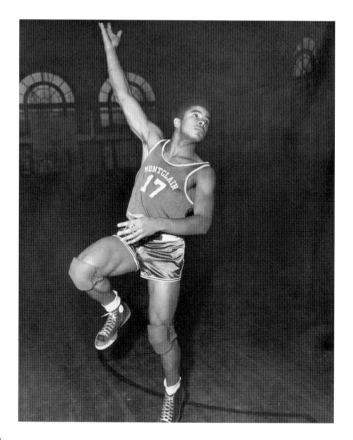

Aubrey Lewis

Lewis may have been the greatest player in the history of Montclair football. The *Star-Ledger* named him New Jersey's Offensive Player of the Century. He also excelled at baseball, basketball, and track, and accomplished all of this despite a heart condition that plagued him all his life.

He was so good that opposing coaches would sometimes ask their players to pick a fight with him. They would get thrown out of the game, but so would Lewis. He kept his composure most of the time, however. Montclair might have gotten a penalty, but he usually stayed in the game. Once, in a game against Clifton, he was the only player standing between three blockers, the ball carrier, and the goal post. Lewis threw himself against the opposing players and knocked all four of them down. He scored 49 touchdowns and ran for almost 4,500 yards in his years at Montclair. He led the team to two state championships, including the 1952 title, which capped an undefeated season. Lewis was also the state champion in the 100-yard dash, the 220-yard run, and the discus throw. He led the basketball team to a 19-1 record in 1952 and an undefeated season in 1953.

He was a star football player for Notre Dame, and became the world record holder in the 400-meter hurdles in 1956. He beat future Olympic medalist Glenn Davis in one race, but fell on a hurdle during the 1956 Olympic trials, losing to Davis. Lewis failed to make the Olympic team. He played one season with the Chicago Bears, but calcium deposits from an old ankle injury, sustained during that incredible play against four Clifton players, forced him to retire from professional sports.

At a College Hall of Fame dinner at the Waldorf-Astoria, Lewis met the head of the FBI's office in Newark. They talked about the FBI's lack of success in recruiting African Americans. Lewis became one of the first black FBI agents, serving for six years. Businesses started courting him. J. Edgar Hoover tried to keep him at the FBI, but Lewis went for the best offer, becoming a manager for Woolworth's. He worked for the company for 28 years, eventually becoming a senior vice president. Lewis grew up at 38 Willowdale Avenue and at 103 Grove Street. He and his wife, Ann, lived in Glen Ridge.

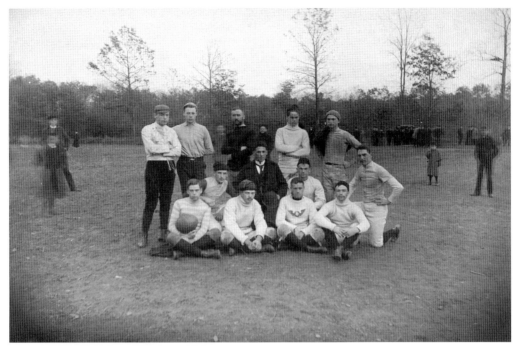

Montclair Athletic Club
The club began operations on Valley Road in 1893. It boasted superb tennis courts, and many tennis greats, including Bill Tilden, Helen Wills, and Suzanne Lenglen, appeared there. People enjoyed playing baseball and lawn bowling at the club. Shown here is a 1900 football team. In 1949, the club was sold to Kimberly, and is now the Montclair Kimberly Academy Middle School.

Montclair Golf Club
The club's first course was north of Chestnut Street, between Central Avenue and Park Street. At the time, the course only had nine holes. The club moved to a bigger lot on Valley Road at what is now Edgemont Park. That lot soon became inadequate to handle the membership. From 1898 to 1900, the club bought enough acreage in Verona to accommodate a full 18 holes. It has since expanded into West Orange.

INDEX

LEGENDARY
LOCALS

AN IMPRINT OF ARCADIA PUBLISHING

Find more books like this at
www.legendarylocals.com

Discover more local and regional history books at
www.arcadiapublishing.com

Consistent with our mission to preserve history on a local
level, this book was printed in South Carolina on American-
made paper and manufactured entirely in the United States.
Products carrying the accredited Forest Stewardship Council
(FSC) label are printed on 100 percent FSC-certified paper.

MADE IN THE

USA